D0295018

Aviation
PHOTOGRAPHY

T. Malcolm English

photographers'
pip
institute press

First published 2005 by
Photographers' Institute Press / PIP,
an imprint of The Guild of Master Craftsman Publications Ltd,
166 High Street, Lewes, East Sussex BN7 1XU

Text and photography © T. Malcolm English 2005 with the exception of
photographs on pages 17 (bottom), 25, 28 (top), 32 (top), 33 (top left)
© Canon; pages 19 (top), 33 (top right), 39 (top left), 46 (bottom left),
47 (top right), 48 © Nikon; page 21 (top) © Pentax; pages 21 (bottom),
27, 33 (bottom left) © Konica Minolta; page 39 (top right) © Apacer;
page 44 (top) © Calumet; page 45 (bottom left) © Anthony Bailey; page 46
(top left) © Tamrac; page 46 © Intermos; page 46 (bottom right) © Sekonic
© in the work Photographers' Institute Press / PIP

ISBN 1 86108 344 0

All rights reserved.

The right of T. Malcolm English to be identified as the author of this work has
been asserted in accordance with the Copyright Designs and Patents Act
1988, Sections 77 and 78.

No part of this publication may be reproduced, stored in a retrieval system, or
transmitted in any form or by any means without the prior permission of the
publisher and copyright owners.

Whilst every effort has been made to obtain permission from the copyright
holders for all material used in this book, the publishers will be pleased to
hear from anyone who has not been appropriately acknowledged, and to
make the correction in future reprints.

The publishers and author can accept no legal responsibility for any
consequences arising from the application of information, advice or
instructions given in this publication.

British Library Cataloguing in Publication Data. A catalogue record of this
book is available from the British Library.

Production Manager: Hilary MacCallum
Managing Editor: Gerrie Purcell
Photography Books Editor: James Beattie
Design: www.mindseyedesign.co.uk

Typefaces: Cargo D and Franklin Gothic
Colour reproduction by Wyndeham Graphics
Printed by Hing Yip Printing Company Ltd.

To Mollie, Josh, Freya and Sam

Acknowledgements

I would like to express my appreciation to the USAF and RAF public affairs officers for the facilities granted to me over the years; in particular Mr Dale Donovan, RAF Strike Command and Capt. Shane Balken, 100th Air Refuelling Wing, Public Affairs Office, USAF. I should also like to thank all of the aircrew I have had the privilege of flying with, whose assistance and professionalism made the air-to-air photographs possible. Last, but by no means least, my sincere gratitude to Jan for her patience and understanding.

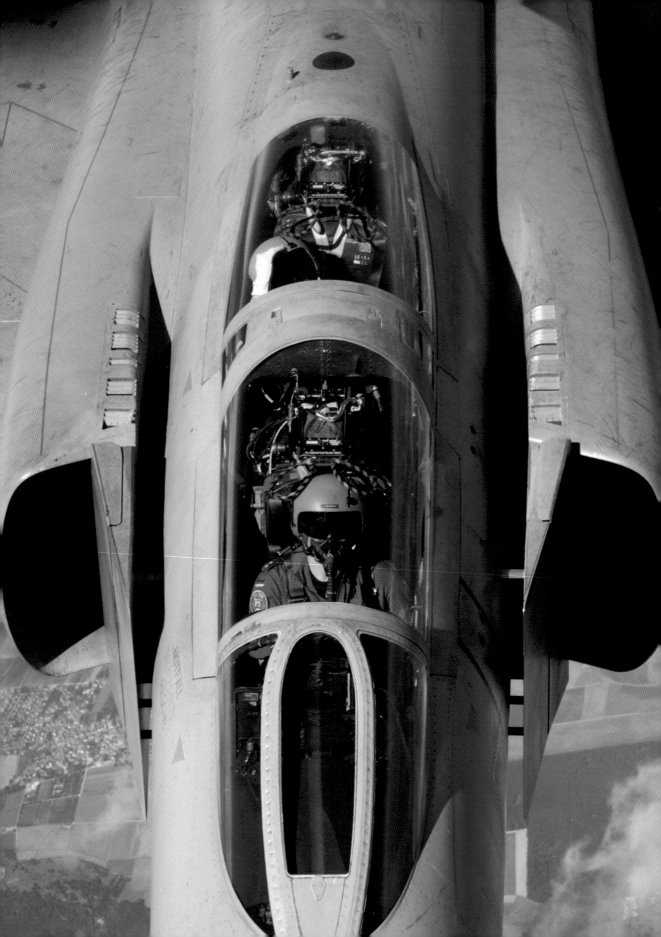

Contents

Introduction

During 2003 some six and a half million visitors attended airshows in the UK, making it second only to football as a paying leisure activity. This gives an indication of the popularity of aviation in the UK, which is mirrored around the world, particularly in the USA and Europe.

Airshows provide a wealth of photogenic subjects, from the opportunity to 'snap' the latest airliner or combat aircraft, to many human-interest subjects such as the spotter with his telescope, or Air Training Corps cadets posing in front of a fast jet for their photograph to be taken.

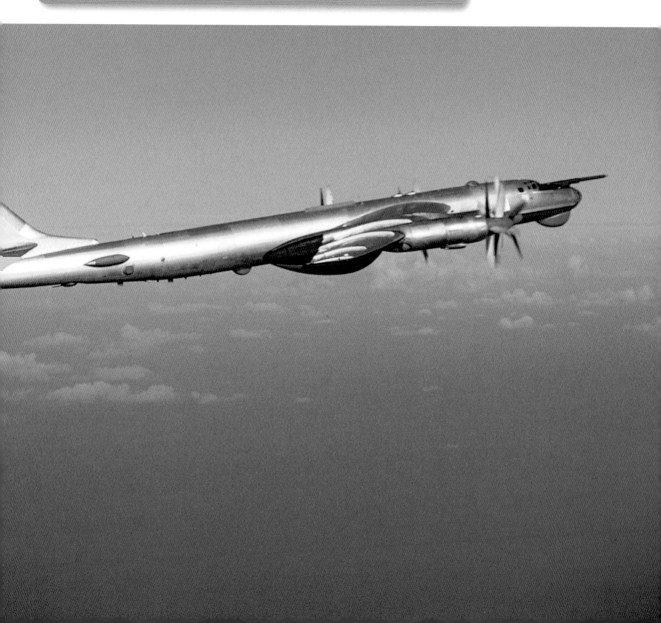

Luck plays an important part in photography. Often it is a case of being in the right place at the right time. Such was the case when a Russian Tu-95 'Bear' maritime patrol aircraft poked its nose into a NATO exercise. Photographs of a 'Bear' and RAF Buccaneers together are extremely rare and it was pure chance that the 'Bear' appeared in one of only two Buccaneer sorties I have flown. At times like this it is difficult to remain composed, so camera operation needs to be second nature.

Airshows are, however, only one of the many sources open to the keen aviation photographer. Airports and airfields provide plentiful opportunities, as do less obvious locations – a light aircraft perched on top of a shopping mall to attract passers-by, or a retired fighter slowly rotting away by the side of a major highway are just two examples.

The ultimate in aviation photography has to be air-to-air photography – capturing an aircraft in its natural environment, with almost complete freedom for composition.

Whilst tumbling around the sky in a fast jet may be beyond the means of most photographers, many owners of light aircraft are only too pleased to have their own aircraft photographed in flight, but be warned: 'you need to learn to walk before you can fly', and one of the intentions of this book is to provide guidance during your early steps.

Some of the facilities now available to enthusiasts were once the preserve of professional photographers. Similarly,

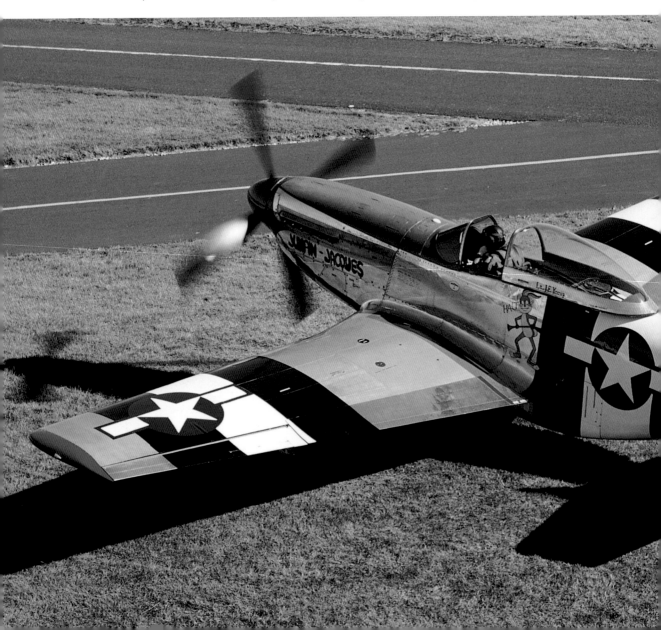

developments in camera technology, particularly affordable digital cameras, have brought 'professional'-specification cameras and lenses within the budget of keen amateurs.

As an example of the advances made in so-called 'snap-shot' cameras, it is interesting to compare my first camera, a Kodak Brownie Cresta – given to me over 35 years ago – with today's equivalent. My Brownie, which I still have, has a fixed shutter speed, fixed-focal-length lens and a

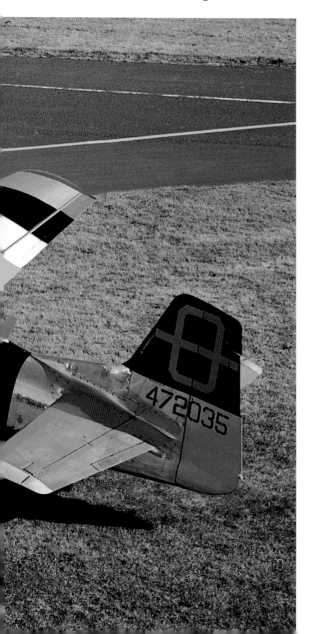

slider, which allows a close-up lens or yellow filter to be positioned over the lens. In contrast, modern digital cameras, and to a slightly lesser extent even film cameras, are micro-computers on a strap. 'Intelligent' algorithms and constantly evolving technology can take care of all but the most complex of focusing and exposure decisions.

Now that cameras have such high levels of automation, and the optical quality to match, it would seem that we should be able to take perfect pictures every time. So where do we go wrong? Well, not all of us own such sophisticated equipment and those who do soon come to realize the truth of the cliché that it is the photographer and not the camera that takes the photograph.

With this in mind, *Aviation Photography* is intended to assist and encourage those enthusiasts who share my love of aircraft and a desire to capture their images, be it digitally or on film, irrespective of the photographic equipment they own. It is also aimed at amateur photographers turning to aviation as a new subject. In writing for groups that include both experienced

Looking more like a model aircraft than the real thing, this North American Mustang was photographed during a family day at Leicestershire Airport, UK. The event was open to the general public and advertised in the local press and aviation magazines. Events like this often attract a surprising variety of aircraft and as they are informal the organizers are often more amenable to requests from photographers for access to the airfield and control tower (from where this photograph was taken).

photographers and knowledgeable aviation enthusiasts, it is inevitable that some of the information in this book will be familiar to some readers. But I hope that there will still be plenty useful snippets for photographers in the sections on 'Equipment' and 'Techniques', and that aviation buffs will find the part on 'Subjects' of interest.

Aviation photography should be fun, but you can make your equipment pay for itself, and there are many markets for competent photographers. Obviously you need to learn plenty about both photography and aviation first, but it is a realistic goal, and I hope that the section 'After the Shoot' will help some readers to take their first steps in the world of semi-professional photography.

Try as I may to avoid using technical jargon, some terms are fundamental to both photography and aviation, but don't let these put you off. Remember that the most important thing is that you enjoy your hobby. Learning the techniques involved is simply a good way of getting more from it, but should never be the goal in itself. That's why this book concentrates on the most important part of aviation photography – having fun and taking great pictures.

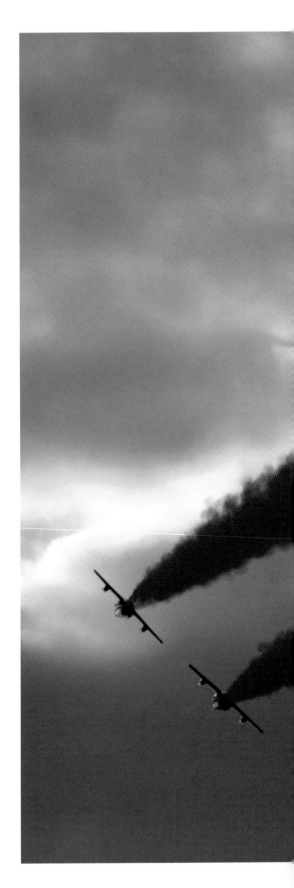

With smoke trails coloured by the setting sun this pair of Folland Gnats makes for an atmospheric subject. Images like this are a great addition to any photographic portfolio, adding creative interest to what are already fascinating subjects.

Equipment

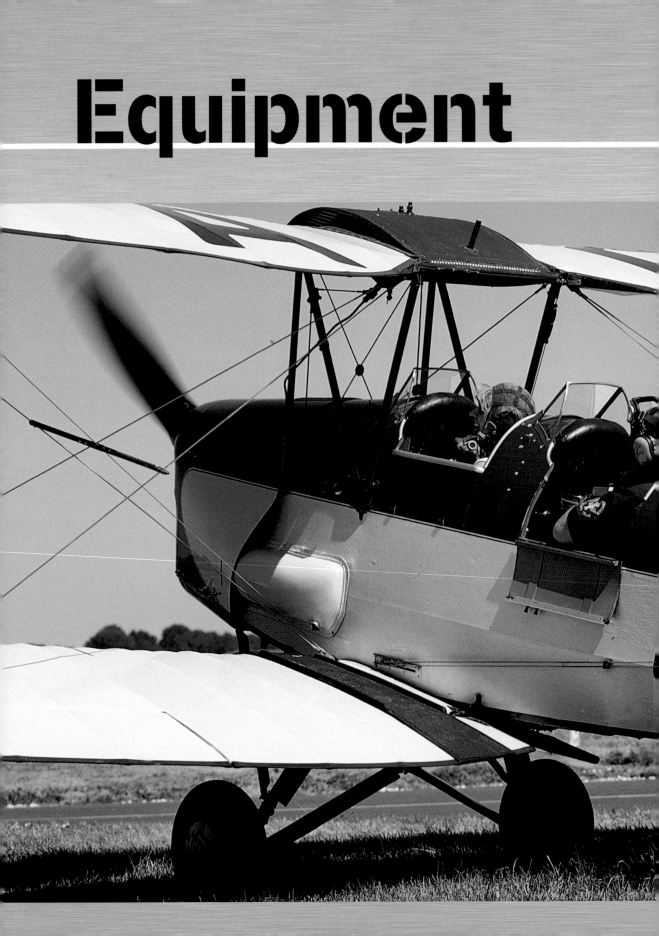

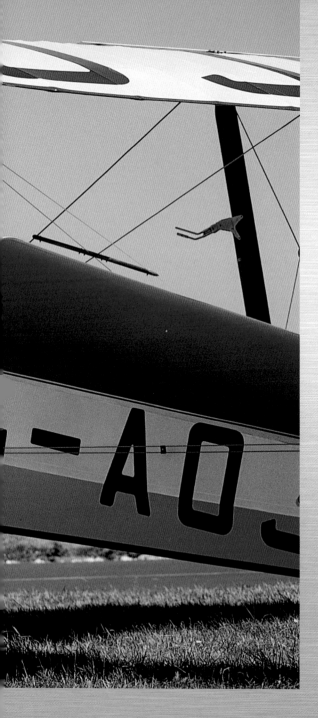

Just like many different branches of photography, the equipment needed depends on the subjects being photographed and the quality required. I should emphasize 'needed' because the power of advertising may lead one to believe that the most up-to-date camera and the longest lenses are essential for a demanding subject like aviation photography. In fact, photographs of aircraft in the static park of an airshow, or of the aircraft you are about to fly off on holiday in, may be easily and satisfactorily taken with something as basic as a disposable camera. That said, the technical limitations of such simple cameras severely restrict the scope of the photographer, not just to take a range of photographs but most importantly to impose his or her creativity on a scene.

⬅ Good equipment helps, but taking images such as this Tiger Moth taxiing at RAF Henlow, Bedfordshire, UK is as much about technique and vision.

Cameras

Dynamic subjects such as aircraft place one key demand on your camera – flexibility. Until the advent of affordable single-lens reflex (SLR) cameras, aviation photographers were limited by the capabilities of the fixed-lens cameras in popular use. Standard lenses are fine for photographing aircraft on the ground, where access is available, but are too short for most in-flight subjects. It is not surprising, therefore, that the most common camera used by aviation photographers is the interchangeable-lens SLR. Consequently, this book has been intentionally biased towards users of these cameras. That said, much of the technology that was once restricted to SLRs is finding its way into other models, particularly the increasingly popular digital compacts.

Broadly speaking there are three types of camera used by amateur aviation photographers today: direct viewfinder cameras, digital compacts and SLRs (both film and digital).

Direct viewfinder cameras

Direct viewfinder cameras include a variety of types. They include a viewfinder built into in the camera body, usually above and to the left of the lens (as you hold the camera), which gives a direct view of the subject being photographed. They cover the spectrum of sophistication, from cheap disposable cameras that you can pick up at the airport before you go on holiday, to the

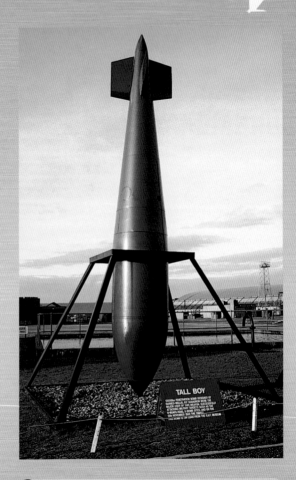

As the information board says, the 'Tall Boy' was used by the Royal Air Force (particularly 617 Squadron) during World War II, to attack a number of targets including the German warship *Tirpitz*. Photographed at RAF Lossiemouth, Moray, UK, home of 617 'The Dambusters' Squadron, images like this can be taken using almost any kind of camera.

famous – and expensive – Leica M series. The most common type of direct viewfinder camera is the compact zoom camera.

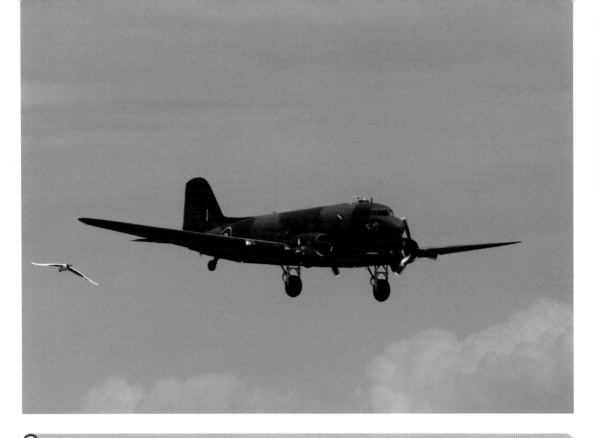

⊕ I'll race you! No, this is not a montage, but a humorous (albeit lucky) juxtaposition of gull and DC-3 as the latter was about to land after a flying display. The 'formation' was photographed with a 100–400mm zoom lens on a digital SLR, and what this and the facing image both show is that it isn't simply a matter of buying the 'best' camera on the market, but choosing the right tool for the job.

The most commonly cited problem with direct viewfinder cameras is that, unlike with SLRs, you cannot see exactly the scene that you are capturing through the lens. However, this is only a real problem when shooting close-ups or when using the most basic models. The real problem is that many compact cameras do not give you sufficient flexibility to capture a range of different subjects in a creative way.

The usual limits on flexibility are a non-interchangeable lens (so you are limited either to one focal length or a range of focal lengths if you are using a zoom), the inability to select shutter

speeds and apertures, and the limited power and positioning of the built-in flash if there is one. All of these become problems either when you try to photograph challenging

subjects – for example a distant plane that requires a long telephoto lens in order to fill the frame – or when you want to impose your own creative vision on a subject.

Having covered the downside of direct viewfinder cameras, there is one very important positive that must be mentioned: their convenience. Most are far smaller and far lighter than their SLR equivalents; this makes it possible to carry them everywhere you go. Always carrying a camera with you enables you to take photographs as and when the opportunities arise; it is often impractical to carry a full camera kit at all times, and direct viewfinder cameras can be a really handy tool to fill the gap.

This convenience is enhanced by their relatively low price (except in the case of the more expensive interchangeable-lens rangefinders on the market). So, regardless of how expensive your 'proper' camera kit may be, it is well worth investing in a relatively cheap model that you can simply keep in your pocket at all times.

Problems caused by viewfinder inaccuracy can include difficulty in correctly framing subjects with some direct viewfinder cameras.

Digital compacts

Digital compacts vary in sophistication from point-and-shoot cameras to those that are almost the equivalent of SLRs, in both price and capability.

The simplest have an uncoupled viewfinder above or alongside the lens, with the attendant problems that were discussed for direct viewfinder cameras. However, most digital compacts also have a liquid crystal display (LCD) screen that may be used for composing the image. Although this lessens the viewfinder problem, it is a digitally generated image. It lacks the quality of an optical viewfinder, and more importantly

there can also be a time lag with moving subjects. One advantage of digital compact cameras is that they generally offer more

⊕ Contrary to the usual need for a telephoto lens to take photographs of aircraft in flight, a modest zoom lens, as found on most digital compacts, was used to capture the Red Arrows framed by a Spitfire.

flexibility than their film counterparts, as they are often part of ranges with a number of accessories such as tele- or wideangle converters. They also incorporate some of the general advantages of digital photography that are examined on page 42.

The usefulness of a digital compact camera depends on the sophistication of the model you buy. By and large a relatively inexpensive digital compact is a great tool. Coupled with the general convenience of digital photography, this makes the digital compact a useful addition to any kit. However, there is one caveat: by the time you have purchased a highly sophisticated digital compact camera you may have spent enough to buy a basic film or even digital SLR system.

⬆ Digital compacts can be great for taking images such as this close-up of the Grumman Hellcat, showing its colourful markings and unit number on the fuselage side. This is just one of around 28 Hellcat survivors and one of thousands of airworthy 'warbirds' regularly flown at airshows around the world. Its gloss finish meant that care had to be taken to avoid glint from the sun.

Digital and 35mm SLR Cameras

SLR cameras and their supporting systems are the most versatile tools in modern photography. They are suitable for a variety of subjects, not just aviation but everything from family portraits to travel and wildlife.

This versatility is due to the wide range of interchangeable lenses and other accessories. The SLR design also alleviates one of the problems that have been discussed about compact cameras: as the image seen in the viewfinder is the same as that passing through the lens, you are essentially viewing the final version of the image. It should be noted that all but the most expensive SLR cameras only represent the central portion of the frame within the viewfinder (approximately 95% of its entirety); however, this isn't normally a major problem and any imprecision can either be cropped out by digital editing, or, when using film, cut off a print or masked by a slide mount.

Other advantages include the ability to measure the correct exposure, and control the shutter speed and aperture settings, which is the key to imposing your own vision on an image. SLRs' autofocus systems are generally more accurate and faster than those of compact cameras, and they can also be switched to manual focus mode. Frame-advance rates (the number of shots per second that you can take when keeping the shutter-release button depressed) are normally fast – especially in the case of more advanced models.

The main disadvantage is the relatively high cost (although second-hand film SLR prices are tumbling as more photographers turn to digital photography, and the prices of digital

SLRs are dropping quickly too). The bulk and weight of some cameras can also be an issue, but these problems pale into insignificance when compared with their flexibility.

Aviation Photography

QUICK TIP

Ideally you should invest in an SLR camera system – these are becoming increasingly inexpensive – however, if you don't feel that you can afford one then don't let this put you off. Great images are taken by photographers, not by the camera, and while everyone is limited to a certain extent by the kit that they own, learning to work within those limitations is far more effective than buying the latest, most expensive camera in the belief that it will magically transform your photography.

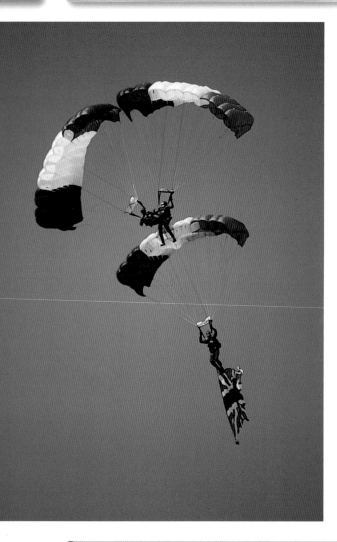

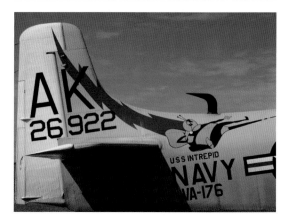

⬆ Details of aircraft, particularly their markings, are useful additions to collections for illustrating features in modelling magazines and articles on those particular squadrons and aircraft types. The tail section of this US Navy VA-176 'Thunderbolts' Douglas Skyraider was photographed during the 2004 Flying Legends airshow at Duxford airfield, Cambridgeshire, UK.

⬆ Parachutists, such as the Royal Air Force Falcons parachute team, are colourful subjects. Their low speed makes them easy to frame in the viewfinder and their closeness to the spectators means that photographs such as this can be taken with a short telephoto lens.

⬆ A 400mm lens was used to isolate this colourful amphibious Catalina from the crowd at the 2004 Royal International Air Tattoo held at RAF Fairford, Gloucestershire, UK. One of the great advantages of SLRs is the availability of a huge range of lenses that make it suitable for every occasion.

FOCUS ON

MEDIUM FORMAT

A few aviation photographers use medium-format SLRs, but the enhanced quality offered by the increased size of the image area often comes at a price, and an increase in both weight and bulk, or a decrease in technology.

For most situations the flexibility required in aviation photography is best met by 35mm or digital SLRs, and the price and unwieldy nature of larger cameras normally make them too inconvenient to use.

Lenses

If you use an SLR (or for that matter an interchangeable-lens rangefinder) you will have a choice of many different lenses. Most 35mm SLRs are purchased with a medium-range zoom lens, typically covering focal lengths of 28mm to 90mm. Those supplied with digital SLRs are normally shorter, ranging from 18mm to 55mm, which creates an approximately equivalent range. This basic lens is suitable for a whole range of subjects from landscape to portraiture, and, within an aviation context, for easily accessible static aircraft. However, there are some situations where a lens with a different focal length will be essential – not normally at the wideangle end, but a longer telephoto lens to fill the frame with a distant subject.

A lens is normally described by two main parameters, focal length and maximum aperture – for example a 300mm f/5.6 lens. The focal length is a measure of the magnifying power: a 300mm lens will produce an image on the film or sensor six times larger than will a 50mm lens

⊙ This view of a small portion of the crowd line at the Royal International Air Tattoo gives an indication of the popularity of air shows, particularly with photographers. With the increasing emphasis on safety the display line has moved steadily further away from the audience; this makes a telephoto lens essential for in-flight photographs.

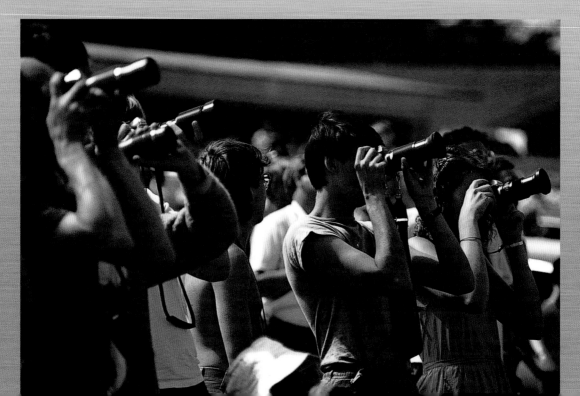

(assuming that the subject distance is constant). The aperture is an adjustable opening in the lens, which determines the amount of light reaching the film or sensor at any one time. Its size is expressed as an f-number: paradoxically, the lower the f-number, the larger the aperture and thus the more light is admitted. The reason for this is that the f-number refers to the size of the aperture as a fraction of the focal length – in fact the 'f' stands for the focal length; so with our hypothetical 300mm f/5.6 lens the diameter of the maximum aperture is 300/5.6 or approximately 54mm. If instead the maximum aperture were f/4 the sum would be 300/4, so the diameter would be 60mm. Hence as the f-number falls the actual size of the aperture increases.

As explained later in the chapter on basic techniques (see pages 52–62), the wider the aperture the faster the shutter speed available. This means that wide maximum-aperture lenses are great for aviation photography, where you regularly need to freeze the motion of a fast-moving subject. Note that some zoom lenses have a variable maximum aperture – for example 50–200mm f/2.8–3.5 denotes that when this zoom is used at the 50mm end of the range it has a maximum aperture of f/2.8, while when used at the 200mm end of the range it has a maximum aperture of f/3.5. As well as these two basic parameters a lens will carry a number of other designations. These normally include: the mount system; whether it can be used with film or digital cameras or both; the focusing system; and any other innovations.

Lenses for SLR cameras are available in focal lengths from about 6mm 'fisheye', to 1200mm, but those at the extremes of the range are very specialized. Lenses are popularly categorized as wideangle, standard and telephoto. This relates to the angle of view of the lens: standard lenses have a similar angle of view to the human eye, while wideangle lenses provide a wider angle of view and telephoto lenses a narrower one. The same system of categorization applies to zooms as well as prime lenses; for example, a zoom may be referred to as a wideangle-to-telephoto zoom lens.

QUICK TIP

What constitutes a wideangle, standard or telephoto lens depends on the size of the imaging area. The size difference between digital sensors and 35mm film means the effective focal length of a lens is increased on most digital cameras (see page 43).

Wideangle lenses

Wideangle lenses offer a wider angle of view than the human eye, and they are often of value when photographing in confined spaces, such as cockpits and hangars, where you cannot move further away from the subject. They are also useful

for static displays, when aircraft are parked close to the crowd line, and for dramatic photographs of aircraft on the approach to land – when access permits.

When you get very close to a subject the effect of a wideangle lens is to distort perspective (see page 35). This can be very useful if you wish to create some dramatic and unusual effects.

A 24mm wideangle lens and low viewpoint were used to emphasize the distinctive nose of this Albatross amphibian displayed at the Coventry Airshow, Warwickshire, UK in 2003.

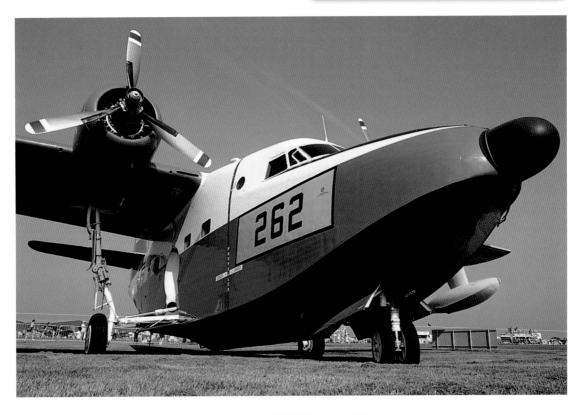

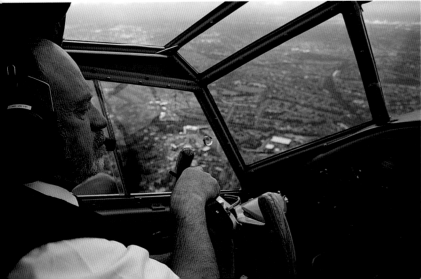

A wideangle lens was used to include as much detail as possible in the rather cramped cockpit of this Junkers Ju52.

Standard lenses

Standard lenses are useful for producing natural-looking images. That said, they can also be a little dull when compared to the large magnifications available with telephoto lenses, or the large amount of information included by a wideangle lens. Don't ignore the benefits of a standard lens, not least the fact that it produces images that relate closely to those seen by the human eye; this is very useful if you are looking to produce accurate record shots, whether of aircraft or events.

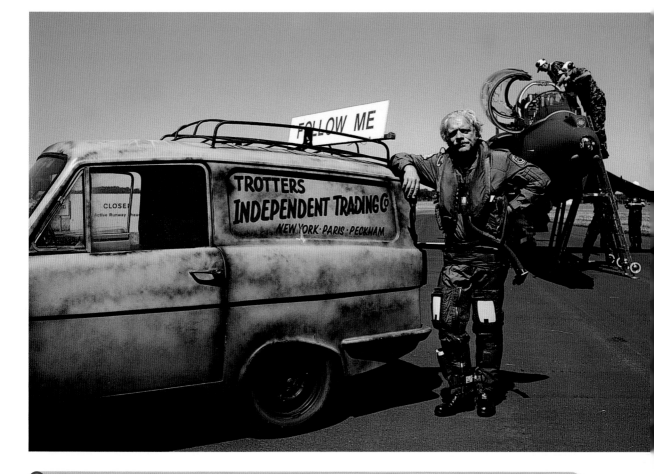

⊕ There was a wonderful photo opportunity when David Jason – aka 'Del Boy' from the BBC's comedy series *Only Fools and Horses* – flew into the 2002 Royal International Air Tattoo in a Harrier and then posed in front of his character's Reliant Robin, which was used as the marshalling van. This is the type of material snapped up by the local newspapers and *RAF News*. A standard zoom lens was used.

Telephoto lenses

Telephoto lenses are particularly useful for action photography – take-off, landing and in-flight – and for taking close-ups of static aircraft. In general, the longer the lens the greater the scope for in-flight photographs.

Using telephoto lenses at wide apertures is also a good way of isolating the main subject from the background. However, long lenses are difficult to hold steady, so you may need to use them with a monopod or other camera support.

Considering the size of the Chinook helicopter, it is surprisingly agile. Attitudes like this, however, need a long lens to capture them – in this case 300mm.

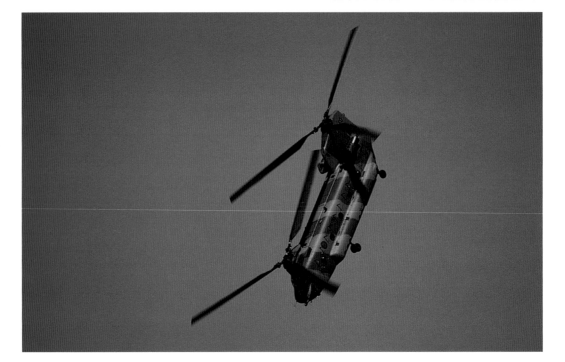

FOCUS ON

CAMERA SHAKE

An empirical rule of thumb states that the slowest practical shutter speed without camera shake becoming visible is the inverse of the focal length of the lens – for example, 1/50sec for a 50mm lens and 1/500sec for a 500mm lens. However, if you can you should avoid hand-holding long lenses and use a support instead, to ensure that your images are pin-sharp.

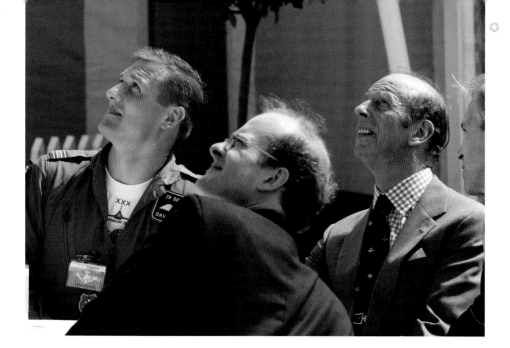

⬆ A telephoto lens enables candid portraits such as this one of Dave Fellows, a 29 Squadron Typhoon pilot (left), and Prince Michael of Ken (right), to be taken without being obtrusive. They were among the VIP guests at the 2004 Royal International Air Tattoo.

⬆ Using a telephoto lens at a distance made this photograph of Taiwanese Starfighters possible. They obligingly waited until the photograph had been taken and I was safely out of their way before taxiing past. The aircraft in the background are blurred due to a combination of shallow depth of field (see pages 58–9) and heat haze from the engine plume.

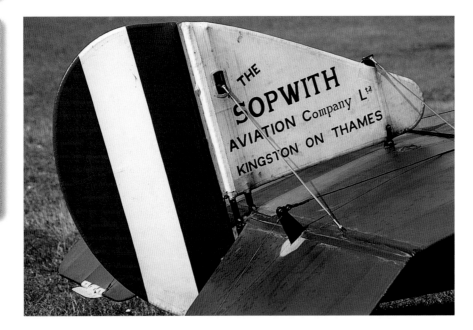

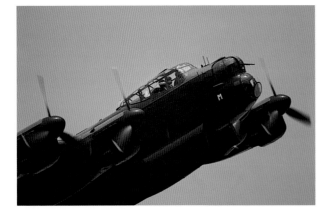

Telephoto lenses enable close-ups to be taken of aircraft on static display. The tailplane of this Sopwith Pup was photographed at Old Warden, Bedfordshire, UK with a medium telephoto lens.

Mirror lenses

Mirror lenses, also known as catadioptric lenses, use mirrors as part of their optical system, enabling them to provide long telephoto focal lengths at relatively light weights and low prices. There are two main problems with these lenses: their low quality and their fixed aperture. Because of the way in which they are constructed, a mirror lens has one aperture (normally f/8), which means that you have little control over the exposure basics of shutter speed and aperture. This can really hamper your creativity. However, you shouldn't discount mirror lenses out of hand – they can be a very cheap option when buying a telephoto lens, and if you would otherwise be unable to afford a telephoto lens they are definitely worth considering.

A 500mm mirror lens is a useful accessory for filling the frame, and in so doing, capturing more dramatic attitudes. This close-up of the Battle of Britain Memorial Flight Lancaster is a good example, and the diagonal composition adds to the impact.

Small aircraft often require a long telephoto lens to fill the frame when they are in flight. A 500mm mirror lens was used to capture this image of a Lockheed T-33.

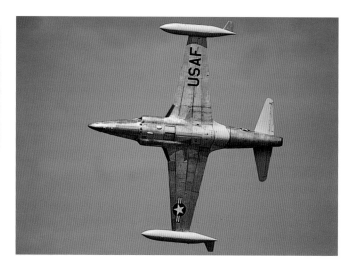

FOCUS ON

FAST LENSES

'Fast' lenses are those that have a particularly large maximum aperture, in other words those that enable you to set fast shutter speeds. These have a number of advantages over lenses with a smaller maximum aperture. As their name implies, for a given ISO (see page 56) and set of lighting conditions, they allow a faster shutter speed to be used in order to freeze the motion of a subject. They also give a brighter image in SLR viewfinders, which can be a boon in dull lighting conditions and when focusing is critical. Autofocus can also be improved as it is carried out with the lens at its full aperture; and they are particularly useful when attaching teleconverters (see page 33), as these can sometimes impinge on the performance of an autofocus system. One of their most useful benefits is that a wide aperture can create a shallow depth of field (see pages 58–9); this can really help to isolate the subject. Nothing, however, is without its disadvantages, and fast lenses are larger, heavier and more expensive than those with narrower maximum apertures.

A 100–400mm zoom lens with 1.4x teleconverter was used with a shutter speed of 1/1000sec to photograph this Swiss Air Force F/A-18 Hornet taking off. Vortices streaming off the wingtips and the undercarriage partially retracted give an added impression of speed.

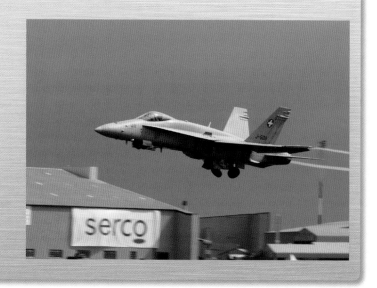

Modern autofocus lenses

Autofocus lenses are now standard and are a great help when photographing fast-moving aircraft – particularly for photographers with failing eyesight or whose reflexes are 'not quite as fast as they used to be'. Even if your's is an autofocus lens it will normally offer the option of switching to manual focus, so there is no real downside to this system. There are several types of fast-focusing lenses

available, and although these will add to the cost of the purchase they are worth having, as they will enable you to capture subjects that may otherwise be moving too fast. Remember, however, that part of the autofocus system of modern cameras lies within the camera body; this means that a fast-focusing lens will only ever be as good as the body to which it is attached.

⊙ It has been said that autofocus lenses have had difficulty focusing on the Lockheed Martin F-117 Nighthawk stealth fighter, but the Olympus Zuiko Digital 50–200mm f/2.8–3.5 lens did not have any such problems capturing this image.

Lenses

Zoom or Prime?

Until the mid-1990s zoom lenses were considered to have an optical performance that was noticeably inferior to their fixed-focal-length equivalents. Although prime lenses (those with a fixed focal length) are still superior in most instances, the difference is now insignificant for most practical purposes, and is more than offset by the ability to change the composition of a picture without moving position or changing lenses. The wide range of zoom lenses now available also means that two lenses can cover a continuous range from around 28mm to 800mm – a range that would otherwise need five or six prime lenses, with the added cost and weight. The main disadvantage of zoom lenses is a consequence of their design, as they typically have a narrower maximum aperture than a prime lens; as has already been explained, this can limit the selection of shutter speeds available.

Teleconverters

Teleconverters are a means of increasing the focal length of a lens. They are simply another optical system that fits between the lens and the camera body, multiplying the effective focal length by the factor of the teleconverter (normally 1.4x or 2x). For example, a 300mm lens with a 2x teleconverter effectively becomes 600mm. Their disadvantages are a loss in image quality (albeit hardly noticeable with the more expensive teleconverters) and a decrease in the maximum aperture, although this depends on the exact teleconverter in use. Bear in mind that not all teleconverters are compatible with all lenses and camera bodies, so check your existing equipment for compatibility before buying a teleconverter.

⊙ Details of military aircraft weaponry, such as the MBDA Meteor beyond visual-range air-to-air missile carried under the wing of a Saab Gripen fighter, are potentially useful for illustrating features on allied subjects. This image was taken with a 70–210mm zoom lens which is great for fine-tuning the composition of the image.

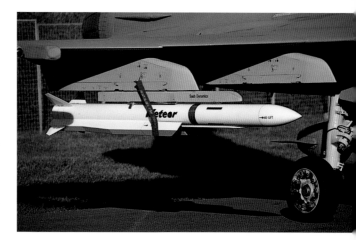

Sometimes a part can be more powerful than the whole, as is arguably the case with this photograph of a P-47 Thunderbolt during take-off. Using a teleconverter allows you to get closer, and here it emphasizes the uneven undercarriage retraction and adds impact to the image.

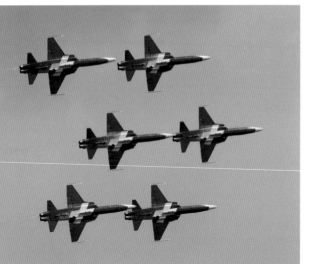

Display teams are adept at choosing photogenically pleasing formations, and often their display commentator will forewarn photographers to have their cameras 'at the ready'. A 100–400mm zoom lens and 1.4x teleconverter were used for this photograph of the Swiss national display team.

FOCUS ON

RENTING KIT

The best-quality lens with the widest aperture, or for that matter the highest resolution digital SLR, are well beyond the means of most of us. However, it is worth remembering that you don't always need to buy equipment to be able to use it – there is plenty of rental equipment available, and at reasonable prices. This can be great if you wish to hire a special item of kit that you wouldn't normally be able to afford, and is definitely an option to consider if you wish to cover a special airshow, or other one-off occasions.

FOCUS ON

LENSES AND PERSPECTIVE

Strictly speaking, perspective is purely an effect of camera-to-subject distance; however, the fact is that the camera-to-subject distance is largely dependent on the lens you use (or vice versa). The closer you move to a subject the further apart the individual parts of the image seem in relation to each other; this explains the distorting effects that are visible when photographing close to a subject with a wideangle lens. At the opposite end of the scale, photographing from far away will cause the individual elements of a scene to appear closer together, so using a telephoto lens from a great distance can 'compress' perspective.

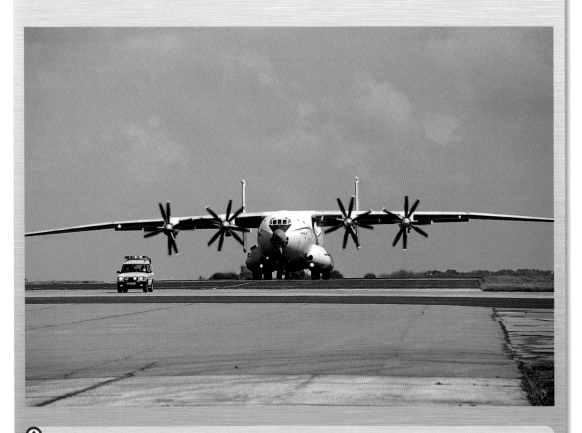

A short telephoto lens used from a distance helps to compress the apparent distance between the 'follow-me' Land Rover and the Antonov An-22, and the vehicle gives scale to the gigantic heavy-lift transport aircraft.

Using film

If you are using a film camera your choice of film depends largely on the subject and the purpose to which the photograph will be put. Will the aircraft be static or in the air, and are the photographs for publication, or personal use?

Film speed

Film speed, indicated on the film package as an ISO (International Standards Organization) number, such as ISO 200, is a measure of its sensitivity to light. Doubling the ISO number represents a doubling in sensitivity; for example, ISO 400 film requires half the exposure of ISO 200 film under the same conditions. Films are readily available with speeds from about ISO 50 to ISO 1600.

A fast film will record detail in lower light conditions than a slow film. It follows, therefore, that the faster the film, the faster the shutter speed that can be selected, or the smaller the aperture for a given shutter speed. Hence, fast film is preferred for action photography and some situations where a great depth of field is required.

Although it would appear that the faster the film, the better, film grain will tend to be noticeable on a 9x enlargement (an A4 – 8¼ x 11¾ – 21.0cm x 29.7cm print from 35mm) with films of ISO 400 and faster. High-ISO films also often have lower colour saturation when compared to slower films. Hence, in general, as slow a film as possible given the situation should be used.

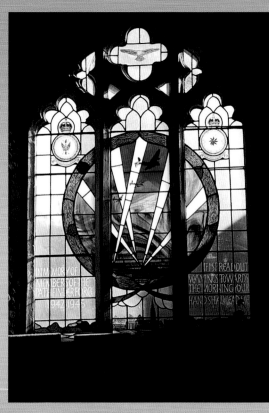

This memorial stained-glass window in St Mary Magdalene Church, Warboys, Huntingdonshire, UK, commemorates the Lancaster crews of 156 Squadron, Pathfinder Force, that were based at Warboys during World War II. It is one of many memorial windows in churches, cathedrals and RAF stations throughout Britain, and was photographed with a zoom lens. A number of bracketed exposures (see pages 85–6) were taken, and using fast film allowed a shutter speed of 1/250sec to minimize camera shake and give sufficient depth of field.

Film type

It is advisable to standardize on only one or two types of film in order to become familiar with the way in which they respond to different lighting conditions. Film emulsions are now so well advanced that there is little to choose between them. Colour rendering is a different matter. As individuals, we see colour in different ways, and arguments will continue forever on which film gives the 'truest' rendering: Agfa, Fujifilm, Kodak and others all have their supporters.

Colour transparency film is the preferred medium for many publishers, and as most of the photographs I take are for possible publication, I use Kodachrome 64 and Fuji Sensia 100. My choice of ISO 64 and ISO 100 is a compromise between the better quality of slower film – which would restrict shooting opportunities with a long lens to bright lighting conditions – and the coarser grain of faster film, less favoured for publication, but more versatile in

unfavourable lighting. In bright sunshine ISO 64–100 allows a shutter speed of around 1/500sec at f/5.6–f/8, which is just fast enough to eliminate camera shake when using a 400mm lens.

For non-commercial photography, the main considerations are the superior viewing convenience and greater exposure latitude (it is harder to make exposure mistakes) of colour negative (print) film, versus the arguably better colour quality of transparency (slide) film. The choice is yours and largely depends on the situation in which you wish to use your images.

⊗ Major airshows and anniversaries seem to be ideal opportunities for squadrons to brighten up their traditionally drab aircraft. For the 2004 display season, this German Navy Tornado sported 90th anniversary *Marineflieger* markings. Photographs such as this are in demand by enthusiast and modelling magazines. If you are thinking of supplying your work for publication, then the higher saturation and better quality of transparencies is a must.

FOCUS ON

HOW MUCH FILM?

Never underestimate how much film you require for a shoot. It is often a good rule of thumb to estimate how much you think you will need and then double it. Running out of film is one of the worst things that can happen, whereas if you look after your film by keeping it in a cool dark place, or even refrigerating it, you can use any that is left over at the next opportunity.

Using digital

The introduction of affordable, high-quality, easy-to-use digital cameras has revolutionized photography. Indeed, it is probably fair to say that the impact of digital photography can be compared with George Eastman's introduction of the Kodak rollfilm camera in the 1880s. In an age where computers are almost part of everyday life, digital cameras – with their ability to produce immediate results 'on screen' (a modern Polaroid) which can be transmitted around the globe – have reintroduced photography to the masses, encouraging more people to take more photographs.

Where digital cameras differ from their film counterparts is in the use of a light-sensitive chip, normally a CCD or CMOS sensor, in place of film, to record light. For the most part a digital camera can be operated in the same way as its film equivalent. Most of the controls on a digital SLR will be familiar to a film user, as will the camera's functioning and capabilities, but there are a few subtle, but significant, differences between the two.

Looking like something out of *Star Wars*, this Northrop Grumman X-47B unmanned combat air vehicle was photographed with a digital camera. It was deliberately photographed into the sun to create an air of mystery, care being taken to shield the lens from direct sun.

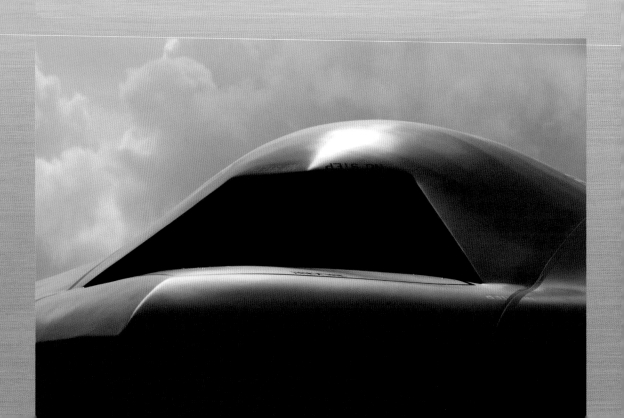

Sensors

The resolution of a digital camera is the number of pixels (picture elements) that its sensor can capture. Essentially, the larger the resolution (measured in pixels), the more information there is within an image and the larger it can be reproduced without degrading. Obviously, as a rule of thumb the larger the resolution, the more the camera will cost, and many people base their purchase on the price-to-pixel ratio alone. However, resolution is not the only aspect of a digital camera that affects quality. Every digital camera is different, so you should read as many reviews as possible before choosing which to buy. Generally speaking a 3-megapixel camera is fine for personal use while a 6-megapixel model offers a resolution similar to professionally scanned slide film.

⊙ With its vertical format, colourful aircraft with wing walkers, and a clear blue sky background, this photograph of an aerobatic team contains all the ingredients for a magazine cover. A clear background is important, to ensure the 'tasters' (magazine contents) stand out. A high resolution will allow the image to be blown up to a sufficiently large size without losing quality.

Memory cards

Unlike film cameras, where the number of exposures is simply dependent on the length of film (usually 24 or 36 exposures in the case of 35mm film), the number of exposures available to a digital camera depends upon the storage capacity of the memory card, and how big the images are (how much memory space they demand). Memory cards come in varying capacities, and may be thought of as being analogous to the number of exposures on a roll of film. The speed of the memory card also affects how quickly it can process images, and the speed of the camera's operation.

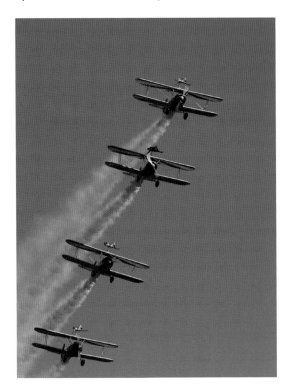

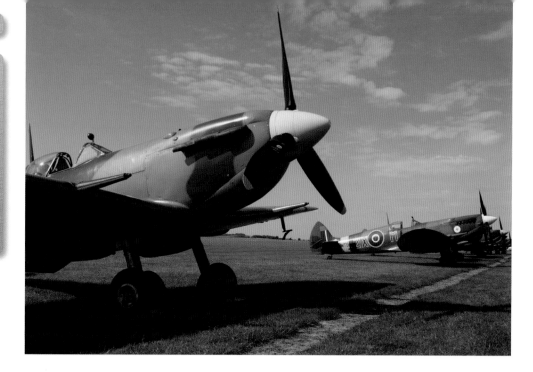

With airshow attendances measured in thousands, patience is a prerequisite for obtaining photographs clear of people (legs under aircraft are a particular nuisance). This was particularly the case with this long line-up of Spitfires, photographed at a Flying Legends day at Duxford, Cambridgeshire, UK, where the public are allowed access along the flight line prior to commencement of flying. Using digital allows you to take a number of shots and use only those which are completely free of distractions or other problems.

File format

Digital SLRs (and other high-spec digital cameras) are capable of recording images in three file formats: JPEG, TIFF and RAW. Which type you choose will depend on what you wish to do with the image.

JPEG (Joint Photographic Experts Group) – This is the most commonly used file format. It compresses the image for easier storage; this slightly degrades the quality, hence it is called a 'lossy' format. However, you can vary the rate of compression, essentially adjusting the quality-to-size ratio for the job in hand. It is very useful for sending images via e-mail or posting them on the Internet where space can be restricted.

TIFF (Tagged Image File Format) – A file format that retains all the quality of the original, but the file sizes are much bigger. This is becoming available on fewer cameras, as it offers neither the flexibility of RAW nor the convenience of JPEG.

RAW – This is essentially the state of the image before any processing is carried out. Files are very large and take longer for the camera to process and store. Some cameras can save RAW and JPEG files simultaneously, and although this is extremely demanding on memory capacity, it has the important advantage of providing a ready-to-use JPEG for many applications, whilst a 'lossless' file

is retained for archiving. Saving an image as a RAW file means that you still have a great deal of control over the image once you have downloaded it to a computer; however, you will need to use specific software in order to access the image.

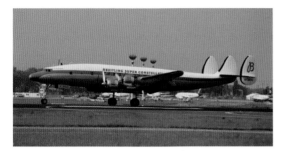 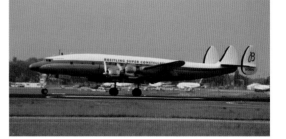

⬆ One of the advantages of digital photography is the relative ease with which corrections can be made with image-manipulation software – such as the removal of these distracting water towers, at Berlin Schönefeld Airport, Germany, from behind the Constellation.

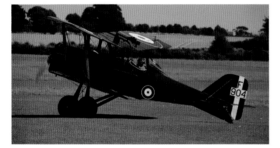 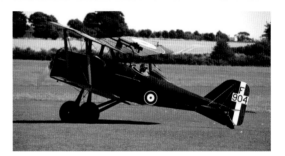

⬆ This photograph of the Shuttleworth Collection's SE5a was converted to sepia by manipulating the image in Adobe Photoshop, and demonstrates just one of the many functions available to users of image-manipulation software.

FOCUS ON

THE BUFFER

By and large you don't need to know exactly how the insides of a digital camera work; however, the buffer is an exception. An image captured by a digital camera needs to be processed into a usable format and have any parameters that have been set applied to it. The speed at which the buffer can operate determines two things: how many frames per second you can take, and the number of shots you can take in a continuous sequence. This is a vital consideration in any purchase, especially if you plan to take sequences of images of fast-action subjects.

FOCUS ON

THE ADVANTAGES AND DISADVANTAGES OF DIGITAL CAPTURE

There are many issues regarding film and digital capture, and it would require a whole book to cover them in depth. However, here is a quick guide to the pros and cons of digital capture.

Advantages

High speed of transmission to friends, family and potential customers with access to the Internet. This is a great asset with topical material, where speed is of the essence.

Ability to change the ISO rating at will. Ideal for those occasions where a range of subjects is being photographed – from static aircraft in sunshine, to those in flight under dull conditions.

A white balance facility, which enables the sensor to compensate for changes in the colour temperature of the light, such as when dealing with artificial light in hangars and museums. Film users would have to use film calibrated for artificial light, or colour-conversion filters.

Retention of the original image, unlike transparencies where normally the original has to be sent to the publisher (unless a copy or digital scan is acceptable).

Image manipulation (such as adjusting the contrast, brightness and colour cast) is easy with proprietary and inexpensive computer software, such as Adobe Photoshop Elements.

Ease of printing your own images, compared with chemical methods.

Low recurring costs through not having to buy film and pay for entire rolls to be developed – you can simply print the image you require.

Exposure and composition can be quickly and reasonably accurately assessed after the photograph has been taken, by using the camera's LCD monitor screen.

Image storage: digital images stored on CDs or DVDs take up much less space than do either negatives, prints or transparencies.

Disadvantages

Like for like, in terms of image quality, digital cameras are more expensive than their film equivalents. (This will undoubtedly change with time, as the development costs of digital cameras are amortized over larger sales.)

As digital cameras record 'latent images', a computer or printer is required to convert them into a tangible medium.

All images have to be 'tweaked' to some extent to get the optimum result.

There can be a noticeable shutter lag – the delay between pressing the shutter-release button and taking the picture. Whilst this is relevant when photographing moving subjects, it may be alleviated by following the subject carefully with the camera.

Digital cameras have a particularly high battery demand, meaning that some can only be used for a limited period before a new battery or a recharge is required. Having said that, the performance of more modern cameras is far improved.

Longevity of the digital images. Whilst CDs and DVDs are the current standard recording devices, it would not be too surprising if they were superseded in the future by a totally new and incompatible system. By comparison, images on negatives and transparencies have the potential of being retrieved forever.

Digital images are arguably more susceptible to corruption or loss than images on film, although this problem can be negated by carefully backing up the files.

Image filing and retrieval can be difficult for those not computer-literate.

FOCUS ON

EXPOSING FOR DIGITAL

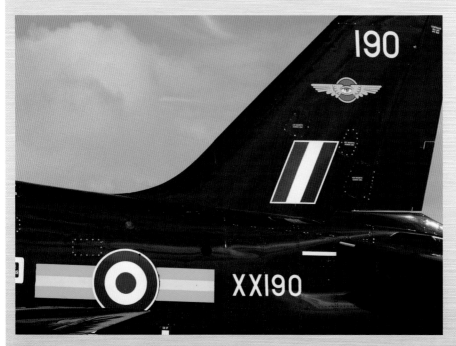

One problem with digital cameras is that they are particularly sensitive to overexposure, when this occurs image detail is lost in the highlights, and no amount of post-capture processing will bring it back. In this instance an exposure about a stop (see page 56) less than that indicated by the camera's meter was required to accurately record the Hawk's 208 Squadron unit markings. Obviously the degree of compensation required depends a great deal on the subject and the way that the particular scene is lit.

FOCUS ON

FOCAL LENGTH MULTIPLICATION

An important factor to be noted about digital cameras is that the effective focal length of a lens is often increased over its 35mm equivalent. Put simply, this is because of the difference in size between film and sensor. The increase is typically a factor of around 1.5 or 1.6, but the Olympus/Panasonic Four Thirds system has an effective factor of 2, due to its particularly small sensor. For most aviation photography this tends to be beneficial in that telephoto lenses are effectively increased in length. However, wideangle lenses are similarly affected and the striking effect that they can create is somewhat negated.

Accessories

There is such a huge range of accessories available for various photographic functions that it is impossible to consider them all here. However, this section lists those accessories I have accumulated over the years and found to be of value in the situations that arise when photographing aviation subjects.

▼ A carefully chosen camera position and a standard lens have been chosen to hide all signs of modernity, giving a timeless photograph of the Shuttleworth Collection's World War I aircraft on the flight line at Old Warden, Bedfordshire, UK. For situations such as this – where a small aperture was used to give maximum depth of field, and ISO 100 film required a relatively slow shutter speed – a camera support is a valuable accessory.

Camera supports

At slow shutter speeds tripods are a useful tool for avoiding unwanted camera shake. However, they can be too ungainly for some situations such as when there are crowds, using a monopod instead is one option. Alternatively, there are a number of other camera supports such as beanbags or specially designed car-window bracket holders that provide enough support to

minimize camera shake, but without the hassle of having to set-up and use a large and unwieldy tripod.

Lens hoods

Most lenses come supplied with a lens hood and some have integral lens hoods fitted. Unless the sun is almost behind your

back, a lens hood is necessary to prevent extraneous light reaching the lens and causing flare, which degrades the image. Even if they don't come supplied with one, most lenses have a specific lens hood that is compatible with them.

The camera angle chosen and the lens hood used were necessary to prevent flare when photographing the natural metal finish of this Lockheed Lodestar at the South African Air Force Museum, Swartkop.

Cleaning equipment

It is amazing how hairs and dust can accumulate, severely degrading images. There is a variety of equipment for cleaning lenses and camera bodies, although digital camera manufacturers warn against using them on sensors. There are sensor cleaners available, but be careful if using them.

Gadget bags

These come in all shapes and sizes to fit a variety of equipment; some even include space for a laptop computer, for users of digital cameras. Points to consider when buying a bag are the degree of protection it will afford your camera(s) and lens(es), as well as its comfort and weight. You should also bear in mind any additions you may make to your equipment, such as another lens or camera body that you might buy.

Motordrives and battery packs

Almost all new film cameras aimed at the enthusiast market are fitted with a built-in motordrive that will offer at least three frames a second. This enables you to keep your eye on the viewfinder throughout a rapid sequence. Some cameras can be fitted with a separate motordrive to improve this rate. Note that digital cameras are restricted in the number of exposures that can be taken in quick succession before the buffer becomes full. However, there are also external battery packs available which increase the battery life of the camera and also provide a vertical shutter-release button that is useful when the camera is being used in the vertical format.

Exposure meters

These are built into most modern cameras. However, if you own a camera, with adjustable shutter speeds and aperture settings, that is not fitted with an integral exposure meter, you can use a separate hand-held meter. Indeed, there are occasions where a hand-held exposure meter can give a more accurate reading, such as incident-light readings. Incident-light measurement is a technique of

determining the light value by measuring the light falling on the subject rather than that reflected from it (see page 83). This is useful in high-contrast conditions, such as an aircraft against a bright sky.

Filters

I have an ultra-violet filter fitted permanently to all of my lenses. Its primary function is to absorb ultra-violet rays and thus reduce the effects of atmospheric haze. It also provides protection for the front element of the lens. Skylight filters can be used for the same job, although they warm the image slightly.

Flashguns

As aviation photography is essentially an outdoor pursuit, there is little need for a flashgun. There are occasions, however, such as in a hangar, museum, or cockpit, where a flashgun is required. Situations such as these often require a wideangle lens. Consequently, if you are likely to take many photographs of these situations, it would be well worth in investing in a

⊕ A telephoto lens allows close-up photographs to be taken without worrying the pilot. Pilots justifiably get rather concerned when anyone gets too close to rotating propellers. Even with a telephoto lens, one should be aware of the propeller slipstream, which can throw debris at the photographer (and lens). Fitting a UV or skylight filter to the front of your lens will help to protect it.

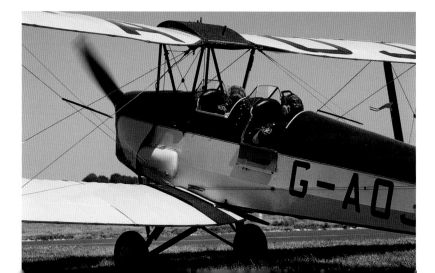

flashgun that has a wideangle-flash capability; otherwise the edges of the image, where the light intensity falls off, will be dark. Likewise, it is worth investing in as powerful a flashgun as you can afford, bearing in mind just how far the distance might be from flashgun to subject. The power of a flashgun is denoted by its guide number – the higher the guide number, the more powerful the flash.

Digital storage

All photographers converting to digital find that they take far more photographs than they ever did on film. As a result, it is all too easy to fill up memory cards if away from your home and computer for any

length of time, particularly when shooting in RAW or TIFF format with a high-resolution camera. To alleviate this problem, there are a number of portable storage devices on the market with a range of storage capacities. These allow you to download images in the field and free up space on your memory card(s).

Understanding your kit

Even the most technically advanced camera coupled to a hugely expensive lens is useless if you don't know how to use it. This may sound obvious, but the increasing complexity of modern cameras can make them tricky to operate. Make yourself familiar with your camera and any accessories that you are planning to use, practise setting particular functions and modes, making sure that you can use the basic functions of your camera without taking your eye from the viewfinder.

FOCUS ON

AUTHOR'S KIT

The equipment you buy will obviously depend upon many factors, not least of which are other photographic interests and finance. Over several years and by buying some equipment second-hand, I have acquired two 35mm SLR bodies, a digital SLR body, zoom lenses from 28–108mm to 100–400mm, prime lenses from 24mm to 400mm, a 1.4x teleconverter, a motordrive, a flashgun (with wideangle attachments), a tripod, UV filters, some cleaning equipment and a large gadget bag. If this appears excessive, remember that it is effectively a 'professional' outfit and has paid for itself many times over in publication fees.

I should add that for a period of about ten years, when I was starting out in photography, I had photographs published in a number of the world's leading aviation and aero-modelling magazines that were taken with much more modest equipment. In fact, my enlarger was constructed from an old oil can, chipboard, a scrap metal rod and a Russian camera lens – which cost me a total of £15 (around $25). So if you are worried that you are unable to afford the very latest and best photographic kit, just remember that it is the photographer and not the camera that makes the picture.

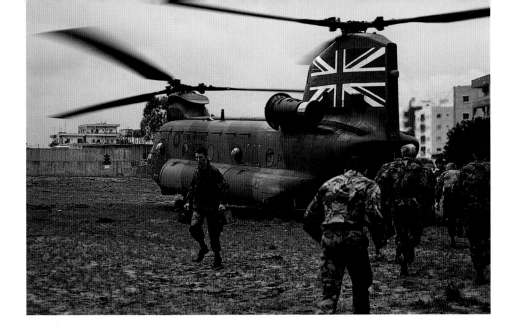

When things get hectic there is often little time to contemplate camera settings. Exposure, composition and focusing have to be second nature. Any hesitation or wrong movement could mean missing the decisive moment. This photograph of troops being airlifted out of Lebanon by Chinook in 1984 was taken on the move as there was every possibility of getting caught up in crossfire.

Always test your equipment before using it 'in anger'. An ultra-violet filter between the wideangle zoom lens and lens hood caused vignetting (see page 51) which was not obvious through the viewfinder in the excitement of photographing Italian Air Force Starfighters from a B-52 Stratofortress.

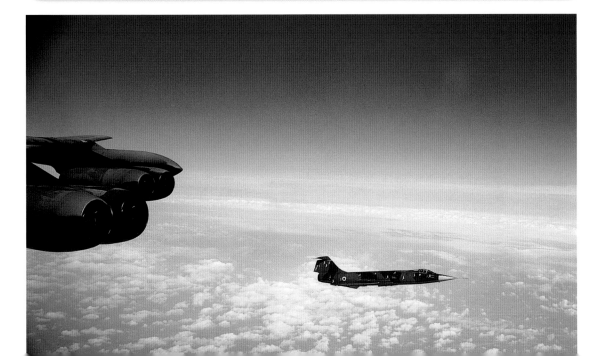

GENERAL

Here are a few tips to help you avoid some of the more basic problems that can spoil your images. While modern cameras have done much to aid photographers, it can be argued that their increasing technical sophistication means that there is also more to go wrong.

Take care when loading a new film or memory card to ensure it is loaded properly. Refer to the manual for instructions on doing this, as, although it is relatively easy, incorrect insertion can damage the camera, and obviously you won't have any pictures to show for your troubles.

'Tramline' scratches on film are caused by grit on the film pressure plate. Dust and grit can be removed by using a blower brush or a can of compressed air. Dust on the sensor can also be a problem with digital cameras; how to clean this yourself is shown in the relevant part of the camera manual. However, it should be noted that this is an incredibly delicate part of the camera and should be treated carefully. If you are in any doubt, then send your camera to an official dealer for cleaning. Another short-term alternative is to use the 'dust and scratches' tool that is a common feature of image-editing software.

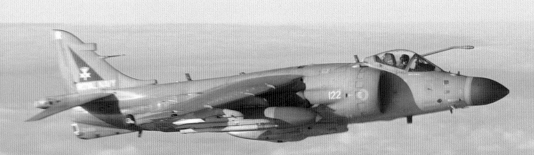

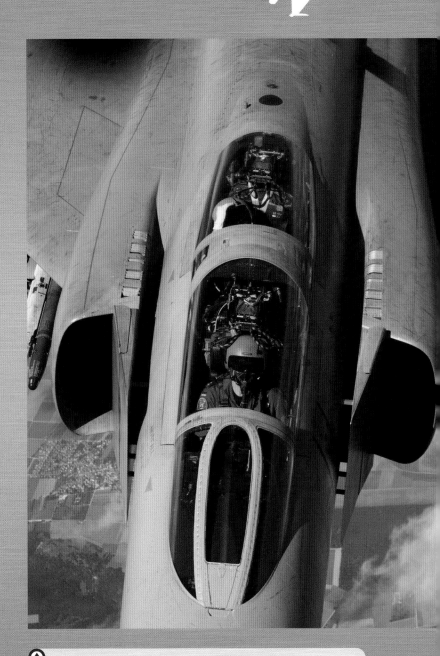

Low contrast, particularly with photographs taken towards the sun, is caused by lens flare. Using an efficient lens hood and keeping the lens clean can prevent this, and many lenses have a lens hood specifically designed to be used with them. Vignetting of the image (dark corners) is often caused by too long a lens hood or too many filters, which protrude into the field of view.

Distortion is often a real problem when photographing through cockpit canopies and cabin windows, and it is not always apparent when looking through a camera viewfinder. This photograph of a Royal Navy Sea Harrier, photographed through the cabin window of an RAF VC10 tanker, is a classic example of distortion and loss of colour saturation.

Whilst optically perfect glass is ideal, do not be too put off shooting through glass with a little inaccessible dirt. This German Air Force Phantom was photographed through a window streaked with hydraulic fluid.

Techniques

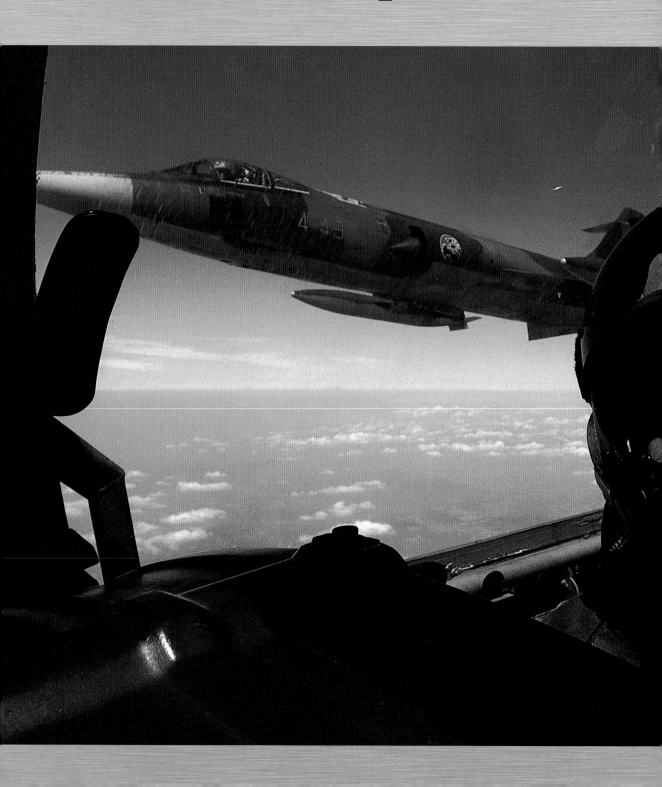

Aviation photography is no different from any other branch of photography in that there are a number of guidelines for such things as composition, exposure and focusing. The operative word is 'guidelines', and the information on the following pages is intended to act as a starting point, from which you can progress and develop your own individual style.

A wideangle lens, with the camera held at arm's length, was used for this self-portrait in an Italian Air Force Starfighter. Hardly textbook technique, but it worked!

Basic techniques

No matter how creative you are, or how high-tech your equipment is, you will need a basic understanding of the techniques that underpin all photographic disciplines. Learning these techniques is relatively straightforward, but will provide you with the know-how to give your images a creative and personal edge that simply pointing and shooting will fail to capture.

Perfect lighting and a neutral grey sky highlight how important accurate exposure is to help to bring this photograph of a Tiger Moth to life.

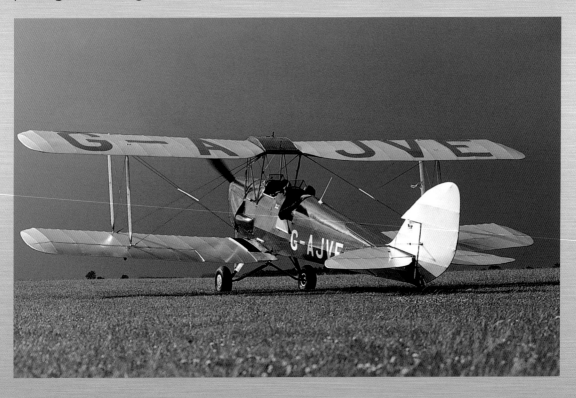

Exposure

The first thing to get to grips with is an understanding of exposure. This is the amount of light that is required to form a correct image on the sensor or film. There are three individual settings that affect the exposure: shutter speed, aperture and ISO.

The combination of these three elements gives an overall exposure value that should be correct for the given lighting. However, the combination of these three elements can be altered, almost endlessly, in order to refine the final appearance of the image.

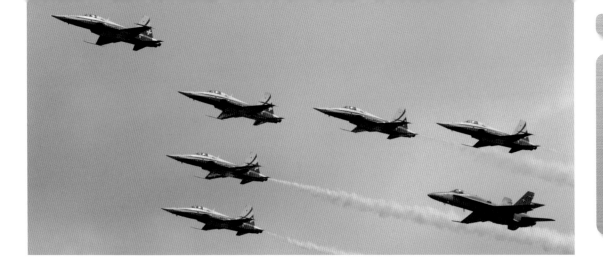

Light-coloured aircraft against a light sky, in this case the Patrouille Suisse F-5 Tiger II display team and a Swiss Air Force F/A-18 Hornet, would have appeared as silhouettes had the lens aperture not been opened up a stop or so to compensate (see pages 82–3).

Metering

The first stage in any exposure is measuring the amount of light required to create an accurate exposure; this is known as metering. Modern cameras have various through-the-lens (TTL) metering modes that can be used to take a measurement of the light reflected from a subject. This reading will then recommend a combination of shutter speed and aperture depending on any settings that you have applied and on the ISO in use. The three most common modes are multi-segment (although what it is actually called will depend on the manufacturer: Matrix for Nikon; Evaluative for Canon; Honeycomb for Konica Minolta; and so on), centre-weighted and spot.

Multi-segment metering takes a reading from the whole of the scene, and depending on how sophisticated the system is, will offer a reading based on the lighting, the subject's position and sometimes its distance. Some even compare the scene to a pre-existing database of information. This is the default mode for most modern cameras and will be reliable most of the time.

Centre-weighted metering is useful when the main subject fills the centre of the frame. It takes a reading from the central area of the viewfinder, which is often denoted by a circle on the focusing screen. This reading is then averaged to take into account the rest of the scene; however, as the name implies, the reading is weighted towards the centre circle.

Spot metering takes a meter reading from a relatively small area of the scene (between 10% and 1% depending on the precision of the camera). This is sometimes linked to the autofocus point that is in use, and is most useful when the correct exposure of a single part of the scene is more important than the rest, or when large amounts of the scene are not midtone (see page 83).

In most situations you can leave your metering system in its default mode. However, there are some situations that are difficult to expose for, and that is where the centre-weighted and spot-metering modes are useful. These situations are covered in the chapter 'Advanced Exposure' (see pages 82–9).

QUICK TIP

The basic measure of exposure is the *stop*. Every time a change is made to any of the exposure variables – ISO, aperture and shutter speed – it can be referred to in terms of how many stops the change is. A one-stop change represents a halving or doubling of one particular exposure variable, how this applies to individual variables is covered over the following pages.

ISO

ISO stands for International Standards Organization, and is a standard measure of sensitivity that, in theory at least, means that one ISO 100 film will require the same exposure as another ISO 100 film, or even a digital camera set to ISO 100. This rating is the basis for the rest of the exposure equation and represents how quickly the medium will react to light.

A film or a sensor's sensitivity to light is often referred to as being 'fast' or 'slow'. Slow films and slow digital sensor settings are those with low ISO ratings; these require more light – either through a wider aperture or a slower shutter speed – in order to obtain the same exposure compared to a faster film or digital ISO setting.

Slow films and sensor settings are generally associated with a better image quality, because the appearance of grain on film and noise in digital exposures will be decreased. Faster films or digital ISO settings are useful in low-light situations, as they will enable you to use faster shutter speeds in any given situation – this can be extremely useful if you are trying to freeze the motion of the subject.

Every doubling or halving of the ISO rating is referred to as a one-stop change. For example, ISO 100 is one stop faster than ISO 50.

It is hardly surprising to see aircraft at an airport – but not in the airport terminal! This replica floatplane hangs in the Marseille Airport terminal building, France, where there was sufficient light during daytime for a hand-held exposure on ISO 100 film. The greatest challenge was in framing the aircraft against as plain a background as possible.

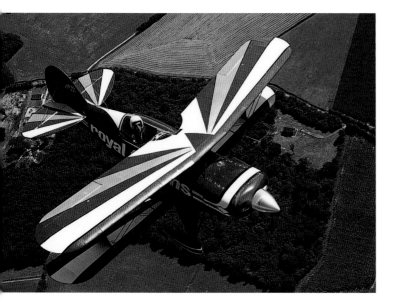

This dramatic shot was taken by leaning out of the Royal Jordanian Falcons aerobatic team's Britten Norman Islander. Because of the almost zero relative speeds and fairly calm air conditions, a relatively long shutter speed was possible (around 1/125sec) enabling the propeller to be well and truly blurred.

Shutter speed

The shutter speed determines how long the film or digital sensor is exposed to light. This determines the appearance of motion in the final image: long (slow) shutter speeds give motion blur, while short (fast) shutter speeds will freeze motion. Obviously this depends on the speed of the subject. Slow-moving subjects can be frozen even with relatively slow shutter speeds; however, faster subjects will obviously require faster shutter speeds to freeze their motion.

When photographing subjects that are static, the shutter speed is only a restricting factor if you are hand-holding the camera.

As mentioned in the box on camera shake (see page 28) the reciprocal rule is a useful guide: you should be able to hand-hold a lens at a shutter speed of one divided by its focal length, for example a 300mm lens at 1/300sec.

Every doubling or halving of the shutter speed is referred to as a one-stop decrease or increase in shutter speed. For example a shutter speed of 1/500sec is one stop faster than 1/250sec, because the shutter is open for less time at faster shutter speeds; this represents a one-stop decrease in exposure.

A 100–400mm zoom lens with 1.4x teleconverter was used to capture this Hercules C-130J on a demonstration tactical-steep-approach landing. In this case a fast shutter speed was useful to make the number of propeller blades clearly visible, thereby identifying the Hercules as a 'J' variant (other models have four blades).

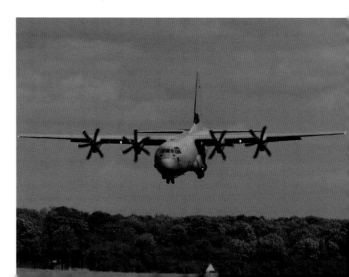

Aperture

The aperture is the opening in the lens through which light passes; its size is controlled by a diaphragm. It is measured in f-numbers, which represent the diameter of the aperture in relation to the focal length of the lens; for example, an aperture of f/4 has a diameter a quarter the focal length of the lens. Therefore higher f-numbers mean narrower apertures while lower f-numbers mean wider apertures. Because of this an *increase* in the f-number represents a *decrease* in the aperture, while a *decrease* in the f-number is an *increase* in the aperture. The numbering sequence of aperture stops (doubling or halving of the light transmitted) is not simple, so here is a list of one-stop changes. (Depending on which camera you use, third- or half-stop increments may also be available.)

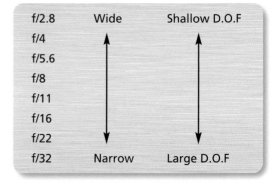

f/2.8	Wide	Shallow D.O.F
f/4		
f/5.6		
f/8		
f/11		
f/16		
f/22		
f/32	Narrow	Large D.O.F

The main effect of aperture is on depth of field. This is the area of the image from foreground to background that appears acceptably sharp. The wider the aperture, the shallower the depth of field; the narrower the aperture, the greater the depth of field. Focal length and subject-to-camera distance also affect depth of field. The further away the subject is from the camera, the greater the depth of field; the shorter the focal length of the lens, the greater the depth of field, and vice versa.

⊕ A large depth of field is required for compositions like this. Fortunately, the Dakotas were still and the light was bright, so it was possible to select a narrow aperture.

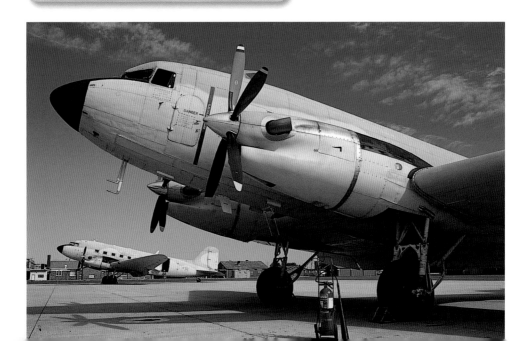

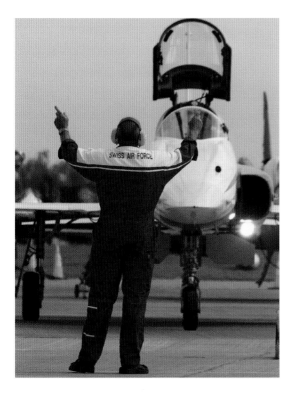

⬆ A 400mm telephoto lens at a wide aperture gives a shallow depth of field, placing the emphasis on the Swiss Air Force marshaller. Everything in the background – including the Swiss national flags and taxiing aircraft is thrown out of focus.

⬆ Although parked tightly among other aircraft, a low camera angle and medium telephoto lens have isolated the nose of this Brietling Super Constellation airliner, proudly displaying the national flags of Switzerland and Germany.

➡ A large depth of field was required to ensure that all of the Patrouille Suisse F-5 Tiger IIs were in focus. Covers placed over engine air intakes, cockpit canopies and the like are normally anathema to photographers, but in this case the yellow jet-pipe covers actually brighten the image.

Putting it all together

Now that you are familiar with the three main exposure controls, it is necessary to understand how they interact. The most common way of explaining this is known as the law of reciprocity. This simply states that the same overall exposure value can be maintained when a change is made to one exposure variable by making an equal but opposite change to another. For example, if the camera recommends a shutter speed of 1/125sec and an aperture of f/5.6 at ISO 100, but you wish to set a faster shutter speed, you can compensate by setting a wider aperture or selecting a higher ISO rating. For instance, selecting a one-stop faster shutter speed of 1/250sec can be compensated for by setting a one-stop wider aperture of f/4 and keeping the ISO at 100, or by selecting a one-stop faster film or digital setting of ISO 200 and keeping the aperture at f/5.6. This ability to change individual variables without altering the overall value allows you to adjust the final appearance of the image without making the overall exposure value incorrect.

There are four main exposure modes that are common to most modern cameras: program, shutter priority, aperture priority and manual. Program mode allows you to alter the combination of the aperture and shutter speed but not the overall exposure. The shutter priority mode allows you to set the shutter speed while the camera selects an appropriate aperture. Aperture priority mode allows you to select the aperture while the shutter speed is set by the camera. In manual mode the camera only recommends the aperture and shutter speed, but you have complete control over the application of both.

Focus

As discussed in the section on equipment, the vast majority of modern camera bodies and lenses use autofocus. The extent to which they are reliable depends largely on the sophistication of the equipment and the situation it is used in. In some cases manual focus can be useful.

Autofocus

Modern autofocus systems are usually very reliable and allow sufficient flexibility for the vast majority of situations. Most cameras feature an array of autofocus points within the viewfinder. You can either select one

A 100mm lens and a shutter speed of 1/125sec were used to capture these Royal Navy Lynx helicopters performing to music, during a Rolls-Royce centenary concert at Donington Park, Northamptonshire, UK. Shutter priority mode was used to set the shutter speed, while the camera set the aperture required to give a correct exposure for the given ISO rating.

manually or you can leave it to the camera. If you are photographing a fast-moving subject, then leaving the camera to select the autofocus point is probably the safest choice. However, if you have the time, selecting an autofocus point that overlays the part of the subject that you wish to be in sharpest focus will help improve accuracy.

Which autofocus mode you use is also worth considering. Most cameras offer a basic choice of two: one-shot and continuous. The names vary from camera to camera, but essentially the first is suitable for static subjects, while the second is best used for moving subjects as it predicts their position at the point of exposure.

Manual focus

Manual focus can be useful either when autofocus fails – if the subject is moving too quickly, the lighting contrast is too low, or there are distracting foreground subjects – or when you wish to focus creatively.

Simply switch the lens (and in some cases the camera body) to manual focus and focus the image by rotating the focusing ring on the lens barrel while looking through the viewfinder. You can also

predict the position of a moving subject and focus manually, before firing the shutter as the subject arrives at the point of focus. Note that more basic compact cameras may not offer a manual focus alternative.

Even though the camera was panned to minimize blur, the Typhoon was flying so fast that the autofocus had a hard job to keep up, and there is still slight softness. That said, it is such a dynamic image that it is more than acceptable up to enlargements of around 10x.

There are numerous airfields where light aircraft, such as this Condor, may be photographed in flight, albeit not being flown quite as exuberantly as seen here. A 100–400mm zoom lens and some panning were needed to fill the frame during its flying display, and the image was focused manually.

FOCUS

Although most SLR cameras now have autofocus lenses, they can be 'confused' by objects moving between the camera and subject, low-contrast subjects and multiple subjects – such as a formation of aircraft. Experimentation is the only sure way to determine your camera's limitations.

At the other end of the technology spectrum, the simplest cameras have fixed-focus lenses, which are usually designed to give a depth of field from about 6ft(2m) to infinity. So, unless taking a close-up detail, all aircraft should be in focus. Blurred pictures are, therefore, more likely to be due to camera shake or subject movement.

It is not unknown for commercially processed photographs to be printed out of focus. That said, it is extremely unlikely and can easily be checked by viewing the negatives through a magnifying glass.

Action photographs taken with manual-focusing lenses can pose a problem, particularly if the lens is zoomed at the same time. Panning, zooming and focusing together is a skill not easily mastered, and (from personal experience) becomes more difficult with the passing of years. For take-off and landing shots, some photographers pre-focus on the point along the runway where the photograph is to be taken. Others, including myself, prefer to follow the aircraft and continuously adjust the focus as necessary. With direct viewfinder cameras, it is usually best to pre-focus, using the marked depth of field scale.

If you are photographing static subjects there is no time pressure so you may want to switch the camera and lens to manual focus so that you can place the depth of field exactly where you want it.

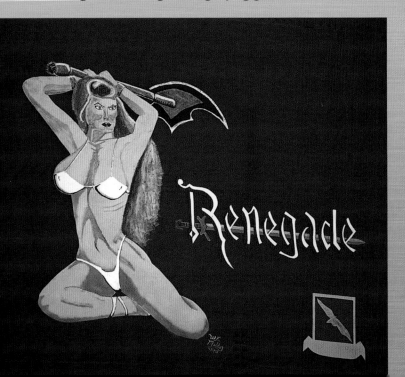

Aircraft nose art dates back to World War I and makes an interesting and often (albeit not in this instance) colourful subject. 'Renegade' was a Rockwell B-1 swing-wing bomber displayed in the static park of the International Air Tattoo in 1992. Static subjects allow you to take your time focusing manually if you have to.

This Lewis machine gun, mounted above the wing of the Shuttleworth Collection's SE5a, is a classic example of the type of subject that is of interest for modelling and general-interest aviation publications. Using the relevant autofocus point ensured that the critical part of the image is sharp.

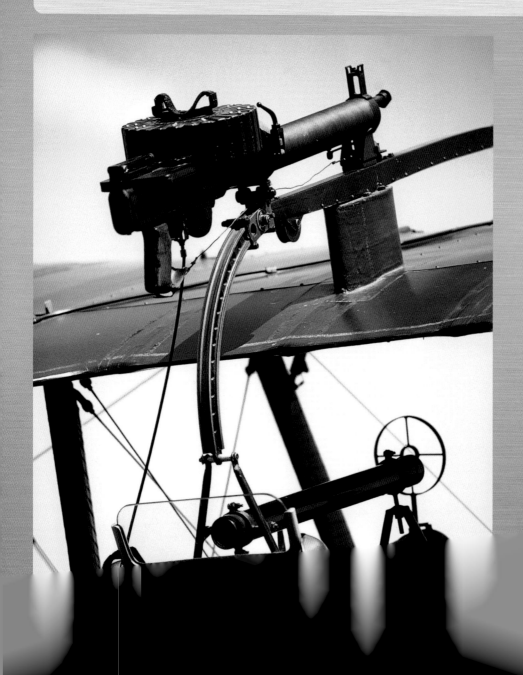

Record shots

Record shots are those taken with the intention of obtaining a true representation of a particular aircraft. Usually, the aim is to include a pleasing composition, which shows the serial number and squadron markings or airline livery.

When taking record shots you should always bear in mind the purpose of each image. What exactly is it about the aircraft that compels you to take the image? Are you trying to capture the form of the aircraft, show a particular detail or perhaps capture its markings? Thinking about what you are trying to show really is of the utmost importance, and your creative licence should take a back seat.

Choosing equipment

Try to use equipment that captures the image as realistically as possible. If you are using film, avoid high-saturation film and choose one that renders colours as naturally as possible. If you are shooting digitally make sure that the auto white balance setting is giving accurate results – adjust it if necessary – and ensure that the colour matrix (sometimes called the colour space or mode) is set to a neutral setting.

Distortion of perspective should be avoided, so unless absolutely necessary do not use a wideangle lens. Zoom lenses are extremely useful, as they allow you to frame the subject in a sympathetic manner. They really come into their own when your movement is restricted and you are unable to move closer or further away from the subject.

Political correctness takes second place to morale in wartime, hence the emergence of nose art as on this RAF Buccaneer, which participated in the Gulf War in 1991. Capturing this kind of image as a record relies on making sure that the colour is rendered accurately.

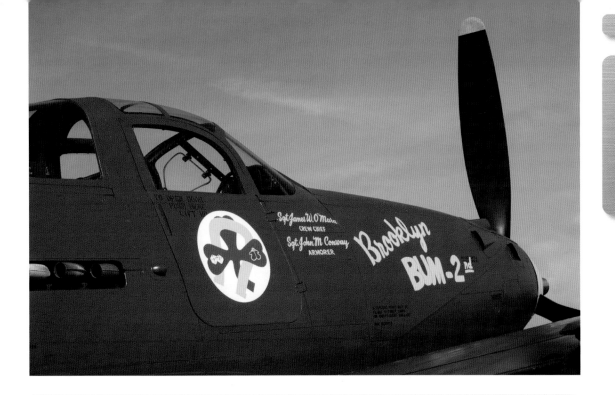

⊕ Among the unusual features of the Bell Airacobra is that the engine is mounted behind the cockpit, hence the inclusion of the engine exhausts on the left of the picture. This arrangement also permitted installation of a cannon in the nose, and the muzzle may just be seen protruding from the propeller spinner. A zoom lens was used together with a low camera angle to include these details against a sky backdrop.

⊕ Perhaps not the most flattering view of an aircraft, but it was chosen to illustrate the arrester hook fitted to this Sea Hurricane.

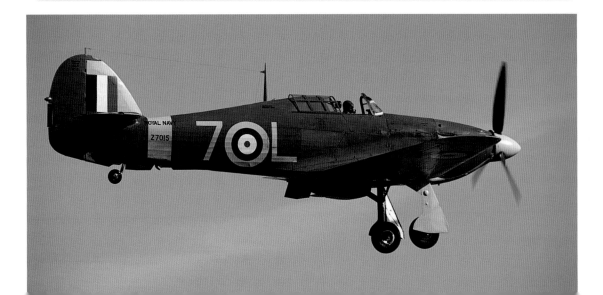

A wideangle lens was used to emphasize the high-aspect-ratio wing of the Lockheed ER-2 high-altitude research aircraft. Unless deliberately planned, care must be taken not to distort perspective when using such wideangle lenses.

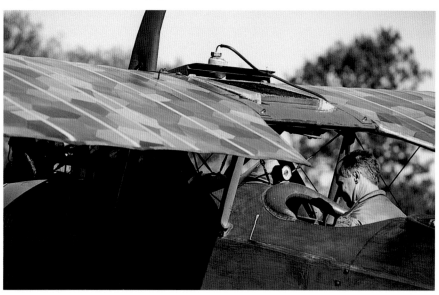

Telephoto lenses are not only useful for subjects at a distance; they can also be used to good effect for taking close-up details. This photograph shows the rich textures of fabric and plywood, and intricate lozenge camouflage on the wing upper surface of the LVG CVI World War I observation aircraft. Until 2003 the aircraft had been based at Old Warden, Bedfordshire, UK, but it is now being prepared for static display in the RAF Museum, Hendon, Bedfordshire, UK.

A telephoto lens, in this case a 100–400mm zoom, is a useful accessory for close-up details such as the propeller spinner of this Royal Netherlands Air Force Fokker F.60. The image has subsequently been cropped to a square format that suits the subject.

Correct technique

Clarity is of the essence for record shots, so a fast shutter speed and/or a camera support such as a tripod should be used to reduce camera shake to an absolute minimum. Lighting is also important, and a bright, sunny day can be a help or a hindrance, depending on the relative position of the sun. Ideally, the sun should be behind the photographer, although you should be very careful to avoid unwanted shadows falling across your subject. While eliminating all shadows might be impossible, especially if your time is limited, you should at least try to avoid them falling across particularly important parts of the image.

Bracket your images (see pages 85–6) to ensure that one of them is correctly exposed, and if you have sufficient light try to use a narrow aperture to create a large enough depth of field to encompass the whole subject or the important part of the subject.

Moving subjects should be photographed with the highest shutter speed possible, in order to freeze their motion.

Compose your subject so that there are no distractions competing for the viewer's attention, and position it within the frame so that important detail can be seen. This often means making the detail or the whole of the subject as large as possible.

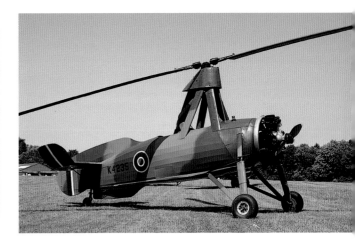

➲ As their name implies, record photographs should be true representations of the subject, without distortion or colour bias. Ideally, they should also be posed against a sympathetic backdrop. This Cierva autogyro meets most of these criteria; the only feature spoiling the image somewhat is the distracting aircraft undercarriage in the background, just visible under the autogyro.

➲ Including people in the frame can provide a sense of scale that can be useful for record shots. This Battle of Britain Memorial Flight DC-3 was photographed carrying out a fly-past of the memorial at Kings Cliffe Airfield, Northamptonshire, UK. A small aperture and high shutter speed were required to give the required depth of field and prevent blur.

Although all of the undercarriage legs should usually be included in a photograph to create 'stability', only having one in this image of a United States Air Force C-21 Learjet does not seem to affect the balance at all, proving that rules can occasionally be broken without undue effect.

FOCUS ON

TAKING THE SHOT

It pays to take photographs of new aircraft as they appear, even if the conditions that you face are less than perfect. You may not get another chance. Such was the case with the Nimrod airborne early warning development aircraft, which was cancelled not long after being displayed at the Farnborough, UK, International Airshow in 1980.

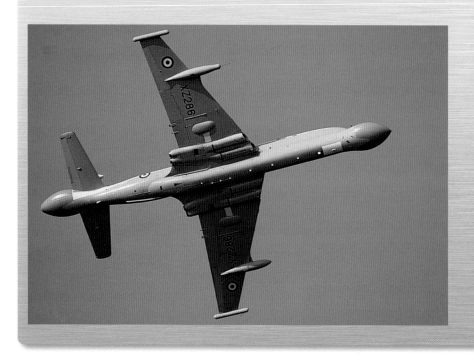

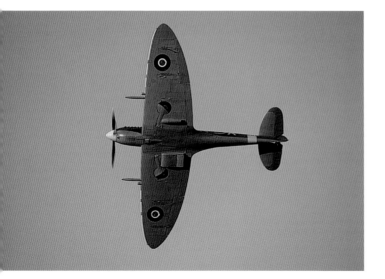

Some aircraft have particularly interesting features that just cry out to be emphasized – such as the Spitfire's elliptical wing. This Spitfire Vc previously had a 'clipped' wing. It was photographed at its home base of Old Warden, Bedfordshire, UK.

Careful study of this close-up of the Avro 504K biplane trainer (photographed with a 300mm lens) shows the weathered logo, and the upper wing and struts reflected in the polished engine cowling. Some 8,000 Avro 504Ks were built, and it was the standard RAF trainer during the inter-war years.

Designed to improve the aerodynamic efficiency of the wing, these winglets on an Embraer 170, taken with a zoom lens, also make an aesthetically pleasing photograph.

Pictorial shots

This is an aspect of photography where individualism comes into its own and rules can be thrown out of the window. Pictorial photographs are those where the subject is presented in a pleasant, sympathetic composition. The almost ethereal sunset photographs of American photographer Paul Bowen are classic examples of this genre.

Pictorial photography tends to be the opposite of record photography in that the aircraft need not be pin-sharp, and the colour rendering should be pleasant, rather than necessarily accurate. Careful exposure is required to obtain the dramatic cloudscapes and silhouettes so often used by pictorialists.

⊙ Almost monochromatic, this photograph of Harrier GR.7s on the flight line at RAF Cottesmore, Lincolnshire, UK, was taken shortly before a violent thunderstorm hit the airfield. Although it is tempting to leave the camera at home when conditions like this are forecast, don't – rain and the odd shaft of sunlight can produce wonders.

Choosing equipment

With pictorial content it is often a good idea to accentuate the colours as much as possible. Use a highly saturated film – transparency is best – and make sure if you are having prints made that you describe the results required to the processor when the negatives are handed in for printing. Otherwise the exposure may be 'averaged out' by the automatic processor and the colours may lose their punch. If you are using a digital camera then you can give the colours an added impact in two ways. If you have the capacity to select a high-chroma, or vivid colour matrix or space, then you should

do so. Also, selecting a white balance that is cooler or higher than the suggested one can warm up reds and oranges.

Interchangeable-lens cameras come into their own for pictorial photography; ultra-wideangle lenses can be used for deliberate distortion of perspective, or to emphasize a distinctive characteristic of the aircraft, such as the high-aspect-ratio wing of a glider or the sheer size of a Boeing 747. Alternatively, a telephoto lens can be used to good effect to photograph a selected area of an aircraft that may be of interest in its own right.

Photographed against a stormy sky, the addition of a splash of orange day-glo colour on the tip tanks of this Silver Star brightens the image.

Using a 400mm lens has isolated the cockpit and high-set tailplane of this Avanti business aircraft, emphasizing its futuristic lines.

Correct Technique

With a pictorial shot it is important that you emphasize the character of an aircraft rather than necessarily recording it as seen.

Try accentuating interesting individual elements of aircraft. Don't just concentrate on the aircraft itself – try taking portraits of the pilot in his or her cockpit, or perhaps including elements of the aircraft's surroundings. Aerobatic teams, with their variety of aircraft, colour schemes and formations, can also make ideal pictorial subjects. Most teams adhere to one or two routines throughout the airshow season, with only minor changes from year to year. Therefore, having seen a previous display, it is a relatively easy matter to plan for the shots you want.

One useful practice that is more common in other fields of photography – such as landscape and wildlife – is shooting when the

Ideally, air-to-air photography requires a camera platform with a clear-vision cockpit canopy, or preferably a removable door. This is an exception in that the Handley Page Victor was photographed from a sister aircraft, and although the cockpit canopy was far from perfect, it has a distinctive atmospheric feel about it – made more so by the inclusion in the frame of some of the Victor's wing and canopy frame.

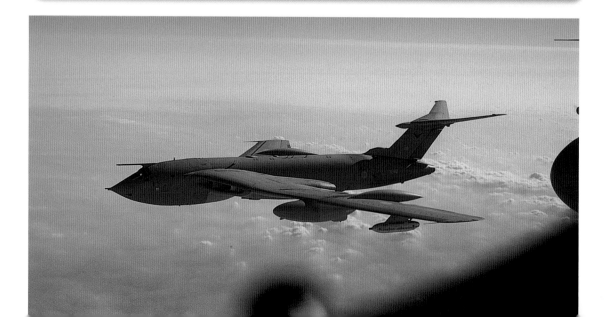

The low-evening light casts a warm glow over the pilot of the Bristol Boxkite. He was photographed with a short telephoto zoom lens, after displaying at one of the Shuttleworth Collection's regular flying evenings during the summer months.

sun is at an oblique angle. This might not always be possible, given the restrictions of airshows on timing and positioning, but when you get the chance, shooting with the sun low in the sky can help to emphasize form and even warm the colours in the image.

Finally, think creatively! There are no limits to what you can do with your pictorial shots. Look around for unusual angles and aspects that are often overlooked. Try using the extremes of exposure (see pages 86–7) in order to create something unusual, and most importantly, don't be afraid of failure, as those pictorial images that are most striking could often be described as being 'incorrectly' exposed or focused.

Reflections of a Buccaneer. This 'touch of David Hockney' was achieved by photographing the reflection of the Buccaneer as seen in the mirrored hangar wall and reversing the image. The exposure was difficult to calculate and a number of shots were taken to bracket the nominal correct exposure. The Buccaneer is privately owned and operated from Cape Town, South Africa.

Action shots

Action shots can be some of the most exciting in the world of aviation photography. However, like pictorial shots they are more challenging to capture than record shots, so here are a few tips to help you create a sense of motion and excitement.

Choosing equipment

In the vast majority of cases it is most aesthetically pleasing to make the subject as large within the frame as possible – given the caveat that it should be allowed space within the frame to 'move into'. This makes telephoto lenses indispensable,

One of the features of modern combat aircraft is their excess thrust. In addition to giving them outstanding combat manoeuvrability, it also allows them to impress airshow crowds with their high angle of attack and low-speed fly-pasts. This makes panning easy for photographers and is an opportunity not to be missed. Smoke canisters (nicknamed 'Smokewinders', as they are based on Sidewinder air-to-air missiles) are also often carried, as by this Royal Netherlands Air Force F-16 Fighting Falcon.

especially when taking images that capture the smaller dimensions of the aircraft, for example dramatic head-on photographs of aircraft in flight. Teleconverters can also be useful for making the subject larger within the frame, although they suffer from the attendant light loss (see page 33) that might restrict the choice of shutter speeds. Cropped-sensor digital cameras (see page 43) really come into their own, as they will render the subject larger in the frame than either a full-frame digital or a film camera will with a given focal length. Zoom lenses are also very useful, as they provide a far quicker way of framing a fast-moving subject than either changing between prime lenses or altering your position.

When choosing the ISO rating of your film, or setting it on a digital camera, you should bear in mind the type of image that you wish to make. Low ISO ratings will help if you are trying to blur motion for more abstract images, while high ISO ratings will help to allow sufficiently fast shutter speeds to freeze action, creating photographs that depict the subject clearly.

Be prepared for fighters to perform a roll along the crowd line if you want to capture photographs like this plan view of a Royal Netherlands Air Force F-16 Fighting Falcon. A 100–400mm lens with 1.4x teleconverter was used to fill the frame.

Some photographers use the 'rapid-fire' capabilities of fast motordrives to take sequences of images in the hope that at least one frame will be successful. Although this technique does sometimes work, others shun such hit-or-miss methods, preferring instead to take one photograph at the instant they believe has the strongest visual impact. Depending on which method you choose to adopt, you may wish to invest in a fast motordrive if you are using a film camera that has the capacity to be coupled with one.

Correct Technique

One of the few rules of photography that is, in my opinion, sacrosanct states that in order to portray motion, more space should be allowed in front of a moving subject than behind it. Otherwise the edge of the frame ahead of the aircraft appears as a barrier to the motion. Prove it for yourself by using a piece of paper to mask off a photograph of an aircraft in flight.

Ideally the subject should be suitably positioned in the frame at the taking stage. If not, most 'unbalanced' photographs on negative film can be recovered by selective printing. Transparencies can also be improved by masking. This is quite easy to do by

Two Royal Danish Air Force pilots relax on their F-16 Fighting Falcon, whilst they enjoy a colleague's flying display at RAF Waddington, Lincolnshire, UK.

Police and air ambulance helicopters are a fairly common sight around the world. This Eurocopter Twin Squirrel, of the Avon and Somerset Constabulary and Gloucestershire Constabulary, was photographed with a 70–210mm zoom lens. Note the sensors in the ball-turret under the nose, looking at the photographer.

Even with a fast shutter speed, panning the camera is a recommended way of preventing a blurred subject. This technique was used to capture a fly-past close to the speed of sound by an F/A-18E Hornet. Humid conditions have caused condensation to form around the cockpit canopy, wings and mid-fuselage, emphasizing the high speed.

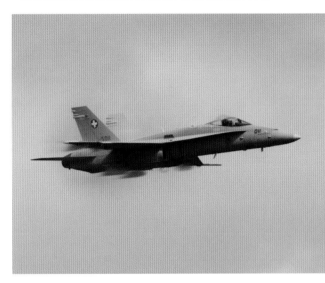

judicious use of aluminium baking foil (folded to give a straight edge) stuck on the emulsion side of the slide with adhesive tape. Digital images can be easily cropped using image-manipulation software.

The key factor in the exposure of moving subjects is the shutter speed (see page 57). The main choice is between using a fast shutter speed to freeze motion or a slower one while panning the camera to create a sense of movement. With fast shutter speeds it is still necessary to pan the camera along the line of flight in order to 'stop' the movement of the subject. When selecting a shutter speed you should consider the type of aircraft and its relative speed. The

important factors of a subject's movement are its speed and direction within the frame – obviously, the closer to the camera, the faster the shutter speed required to freeze its movement. If it is moving towards or away from the camera, then panning will be less effective than when it is moving across the frame, so again you should adjust the shutter speed accordingly.

If the aircraft is propeller- or rotor-powered, then contrary to the general advice to use as fast a shutter speed as possible, the opposite is recommended, as shutter speeds of 1/500sec and above may make the propeller or rotor, appear stationary and look unnatural.

If you wish to capture a more impressionistic depiction of movement, a slow shutter speed can be used. Normally, when using a slow shutter speed, the camera is panned, thus blurring the surroundings. Alternatively, the camera can be held steady, while the subject moves across the field of view and is itself recorded as a blur. This may be used to good effect when photographing aircraft being catapulted off the deck of an aircraft carrier, and airliners on approach to land at airports. The technique is particularly impressive with night shots (see page 109). Remember that you are only trying to depict subject motion, and camera shake can still be unappealing; this means that a camera support can be a useful tool.

⊕ Helicopters are among the easiest aircraft to photograph in flight, as they tend to be slower moving than most fixed-wing aircraft and often fly closer. The combination of a shutter speed of around 1/500sec and panning the camera has given some motion to the rotor blades of this Swedish Air Force Eurocopter Cougar whilst the fuselage is pin-sharp.

⊕ This sequence of photographs illustrates the effect of shutter speed on propeller movement. The Hawker Hind was photographed at 1/30sec (top), 1/125sec (middle), and 1/500sec (bottom).

A slow shutter speed (necessitated on this occasion by the low light level), and panning the camera portray speed as the 1910 Deperdussin takes off on one of its rare flying displays at Old Warden, Bedfordshire, UK.

FOCUS ON

THE DECISIVE MOMENT

In order to capture the decisive moment it is important that you can predict the movement of the subject and depress the shutter-release button a fraction of a second before the critical moment arrives.

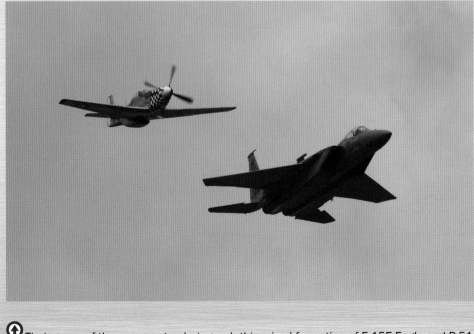

Timing was of the essence to photograph this mixed formation of F-15E Eagle and P-51 Mustang. Too early and they were but specks in the sky, too late and one obscured the other as they flew by.

MOVEMENT

Problems with movement within the frame are normally caused either by camera shake or subject movement. The former has occurred when there are signs of blur all over the picture. It can be cured by taking care to hold the camera steady, using as fast a shutter speed as possible and pressing the shutter-release button smoothly. Alternatively, if it is possible to use a tripod, a monopod or simply rest your camera on a convenient perch, then do so.

When blur is caused by subject movement, some parts of the picture will appear sharp. While this is not necessarily a bad thing, the effect can be overused and render subjects indistinct. Using a faster shutter speed, panning with the aircraft and photographing it as it moves towards or away from the camera, rather than across the viewfinder, can reduce the risk of subject blur. When panning with the aircraft, care should be taken to continue the pan while the shutter-release button is pressed. This is particularly important with older digital cameras, where there may be an appreciable lag between the shutter-release button being pressed and the image being recorded.

Movement can also cause problems with composition, and you should take every piece of help available to get the moving subject in the right part of the frame. This can include studying programmes before the event, asking the organisers for information, and best of all familiarizing yourself with any display routines.

◉ A wideangle lens was used for this atmospheric photograph of the RAF's Red Arrows. Familiarity with the team's routine enabled me to predict the manoeuvre and plan the shot.

Advanced exposure

The foundations of exposure control were covered in the chapter on basic techniques (see pages 54–61); however, there are some situations in which the basics go out of the window.

Under- and overexposure

Most metering systems are based on the concept of a midtone subject: the meter reads the amount of light reflected from the subject and recommends an exposure to render it as a midtone. Obviously this is a simplification, and more sophisticated systems incorporate far more information than this; however, it is worth remembering that the basis of the metering system is the concept of midtone. The effect of this is that the camera will get 90% of its exposure recommendations spot-on; however, when

Relatively dark backgrounds such as this can cause problems with the accuracy of the exposure. Learning how to make accurate exposures in difficult circumstances is a key part of getting the most from every shooting opportunity. This Miles Master is giving a display at Old Warden, Bedfordshire, UK, reminiscent of the barnstorming days.

⬆ Dark subjects, such as this pilot in the cockpit of his Italian Starfighter, tend to make lightmeters overexpose.

the subject or large parts of the background are very different from a midtone it may cause under- or overexposure.

Some subjects may not contain an average-tone area at all – for example an aircraft silhouetted against a bright sky, or a close-up detail of a dark aircraft such as the Lockheed U-2. In situations such as these, there are three methods of determining the correct exposure: either find an alternative (substitute) midtone subject, use an incident lightmeter, or take a meter reading of the scene and adjust the exposure to compensate for the brightness or darkness.

Substitute readings

The first of these methods requires an understanding of the areas covered by different metering systems, see page 55. This is where the spot-metering mode comes into its own; using this mode you can meter from a very specific midtone area of the scene before locking exposure and recomposing to take the image.

Incident readings

Taking an incident light reading means taking a reading of the light falling on the scene. This requires a separate incident lightmeter; it also requires you to take the reading in the same light that the subject is in. While this may be possible with static displays, it isn't feasible for action shots. While separate lightmeters can be useful, they are a bit of a luxury, and you should be able to get by using the other two methods covered here.

This low-key treatment of the Lockheed U-2 was deliberately chosen as being appropriate for what was once one of America's most secret 'black programmes'. The exposure was based on a reading of the grey sky.

An incident light reading was taken from a hand-held exposure meter to calculate the camera settings for this yellow Starfighter, sporting special squadron anniversary markings, framed against the dark hangar interior.

Estimation

Estimating the degree of correction that needs to be applied to the exposure reading will come mainly with experience. As a guide, if you think that the image might suffer from overexposure – in other words if the subject or the background is very dark – then apply negative exposure compensation (almost all SLR cameras have a button or dial for this function) or decrease the overall exposure value by selecting a narrower aperture or a faster shutter speed in the manual exposure mode. If you think that the image might suffer from underexposure – which it may if the subject or the

background is very light – then apply positive exposure compensation or increase the overall exposure value by selecting a wider aperture or slower shutter speed in the manual exposure mode.

Bracketing

If you are uncertain whether or not you have achieved the correct exposure, then bracket the exposures, widening and narrowing the aperture setting, or increasing and decreasing the shutter speed, either side of your estimated exposure. Most SLRs have an auto-bracketing function. This should

Not the easiest of colour schemes to photograph. A number of photographs of this Antonov An-2 were taken with the exposures bracketed in order to ensure that detail was retained in the highlights.

give you a choice of images at a variety of subtly different exposures. However, you should be careful when you are photographing moving subjects, as bracketing can result in the correctly exposed image being in an unfavourable composition.

Creative exposure

Remember that the definition of a 'correct' exposure depends on the purpose of your photograph. If you are trying to obtain an accurate record of the aircraft, then the purpose will be to render the tones and colours of the aircraft as accurately as possible. However, if you are trying to make a more creative image then exposure can be used as a creative tool. The effects of the principal individual elements of exposure – shutter speed and aperture – have already been discussed. However, altering the overall exposure value can also

Particularly careful metering was needed to get full colour saturation of this Neptune water bomber disgorging its load during a flying display in Chile. Even slight overexposure of the orange aircraft or deep blue sky would have significantly reduced the impact.

FOCUS ON

DIGITAL EXPOSURE

There are two key advantages to digital photography, when faced with difficult exposure situations. The first is that you can check the exposure on the rear LCD monitor. There are a number of ways of doing this, but the most accurate – if your camera offers it – is the histogram function. This displays the range of tones within the image from pure black to pure white. Using this tool you can adjust the exposure so that you don't lose large amounts of shadow or highlight detail by having these areas registering as pure black or pure white. The other main, and extremely useful tool is the RAW file format. If you are uncertain of exposures, then make sure that your file format is set to RAW (NEF if you use Nikon cameras); this will allow you to adjust the exposure of the image later on computer.

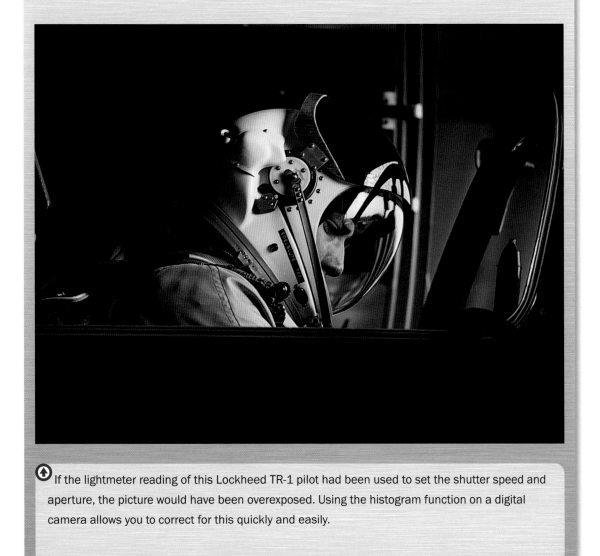

⊕ If the lightmeter reading of this Lockheed TR-1 pilot had been used to set the shutter speed and aperture, the picture would have been overexposed. Using the histogram function on a digital camera allows you to correct for this quickly and easily.

create images with a difference. Deliberately underexposing an image will – depending on the extent to which it is underexposed – render the subject as a silhouette. The opposite end of the spectrum can also be utilized, and high-key images can accentuate certain themes within an image or even place the emphasis on a particular part of the aircraft.

Starburst effects can be achieved by decreasing the aperture and including the sun in the frame. In this case, scratched glazing in the Royal Air Force VC10 cabin window, through which this photograph was taken, has heightened the effect. The photograph of the Jaguar GR.3 was deliberately underexposed, to give a silhouette of the aircraft.

FOCUS ON

KEEPING SHOOTING!

When the weather takes a turn for the worse it is very tempting to pack your kit away and come back on a sunnier day; however, stormy skies are often a spectacular backdrop for your subject, whether on the ground or in the air. They can provide images with bags of atmosphere and make your portfolio of photographs that little bit more varied.

There is a great temptation to pack your camera away if the weather is dull, but this photograph of a Lockheed 12A shows that it is worth persevering. The silver aircraft is in perfect harmony with the menacing dark grey sky. That said, there was a mad dash for cover minutes later as the rain came down!

EXPOSURE

The most common fault when exposing aircraft in flight is that the subject appears in silhouette. This is normally due to the meter being biased by the dominating mass of bright sky, as described in the section on advanced exposure, see pages 82–3.

Compensating for this will take some experience, and ways of doing this are examined in detail on pages 83–6. Dark subjects will sometimes be rendered lighter than they should be; again, you can learn to predict when this will be the case and correct for it using the advice on pages 83–6.

Exposure errors can also occur at the printing stage, particularly if there are extremes of contrast. When you think this may be the case with commercially printed photographs, do not hesitate to ask the processing company for advice and request that the negatives be reprinted.

Burnt-out highlights are a particular problem with digital cameras. The reason for this is that white pixels contain no image data, and if there is nothing there in the first place no amount of processing can rescue detail. With this in mind many digital photographers choose to shoot with exposure compensation of –1/2 or –2/3 stop applied at all times. Then, if the image requires brightening up, this can be done later, most easily if the images are shot in the RAW format.

⊕ This colourful Gulfstream IV business jet was photographed at Las Vegas International Airport using a standard lens. Careful exposure was needed to retain detail in the white fuselage.

Composition

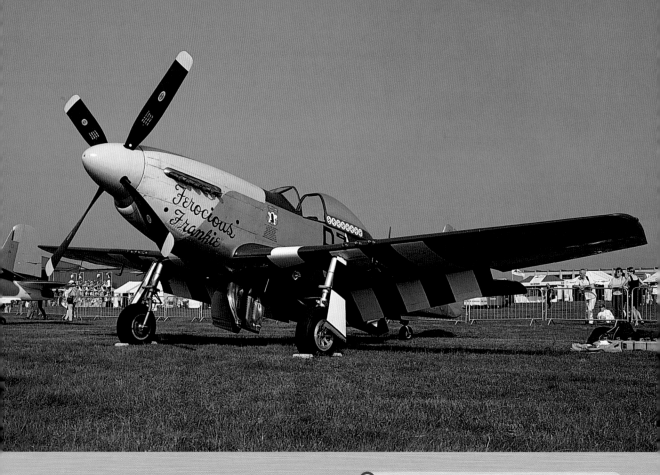

The composition of your image is immensely important, but it is often completely overlooked. As was described in the chapter on action shots, the positioning of the aircraft in the frame has a great effect on the 'feel' of the image. Aircraft photographed side-on at ground level tend to be rather unexciting. Being long and thin, their geometric proportions are less than ideal for fitting film or digital sensor formats.

A low camera angle, such as was adopted for this P-51 Mustang, can sometimes be used to hide a distracting background. In general, the longer the lens, the easier it is to concentrate attention on the subject.

Point of view

There are, of course, many situations where the photographer has little or no control over the positioning of the aircraft. Even so, it is often worth raising or lowering the camera angle. This usually means lying on the ground or standing on a stepladder. Lightweight stepladders are a very common sight at airshows and are extremely useful for photographing over the heads of your fellow spectators.

Don't just consider the height from which you shoot; also think about your position relative to the aircraft. When you have some control over your positioning relative to the subject, as may occur at an airfield with light aircraft, or at a museum, you should spend some time walking around the aircraft for the best camera angle. A three-quarter front or rear view is often more dynamic than a side view, particularly when photographed from a low viewpoint.

⊙ By using a high vantage point – in this case the upper deck of a bus – this Spitfire appears to be flying lower than it actually was. Including the buildings in the background adds to the effect.

Angles such as this are useful for emphasizing a host of aspects of an aircraft that would otherwise be lost in a standard record shot. This view clearly illustrates the distinctive scimitar propeller blades of the ATR 72 and the wonderful colour scheme of Bangkok Airways.

Look for the more unusual angle. Although not a particularly flattering photograph of one of the most sleek fighter aircraft – the F-16 Fighting Falcon – it is just what aircraft modelling magazines are looking for. Among other things, it clearly shows the open airbrakes, brake parachute and jet pipe nozzle details. Sloping horizons are an ever-present danger when taking photographs such as this, as it is all too easy to concentrate more on fitting the relevant parts in the frame.

FOCUS ON

FRAME FORMAT

All too often photographers take images in the horizontal format simply without thinking. However, very often the subject or the purpose to which the image is to be put dictate that a vertical format is more appropriate. Often it can be useful if you are thinking about submitting your work for publication (see pages 152–61) as it fits the standard format of the printed page. Always think about different ways of framing your subject, and if possible, capture the same aircraft in a number of different compositions and frame formats. Each might be useful for a different purpose, especially if you choose to submit your images for publication.

What to include

At the risk of stating the obvious, the composition will be determined largely by the purpose for which the photograph is being taken. If the photograph is intended to illustrate an airshow, then it may be beneficial to show the subject amongst other participating aircraft. Similarly, the location where the photograph was taken may be important, so look out for a control tower or passenger steps bearing the name of the airport. On the other hand, if the image is for a personal record, you may wish to isolate it from other aircraft.

⊕ Film sets can offer opportunities for photographers forward enough to ask for permission to take pictures. This was taken at Duxford, Cambridgeshire, UK, during the filming of *Memphis Belle* and only the modern van seen below the distant B-17 Flying Fortress reveals that its was not photographed fifty years earlier.

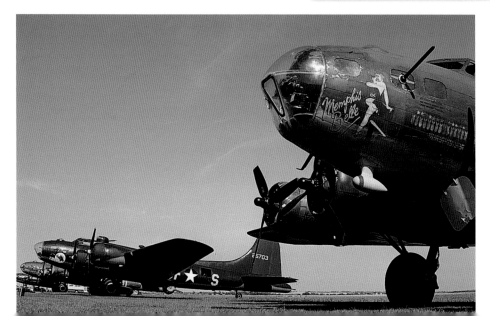

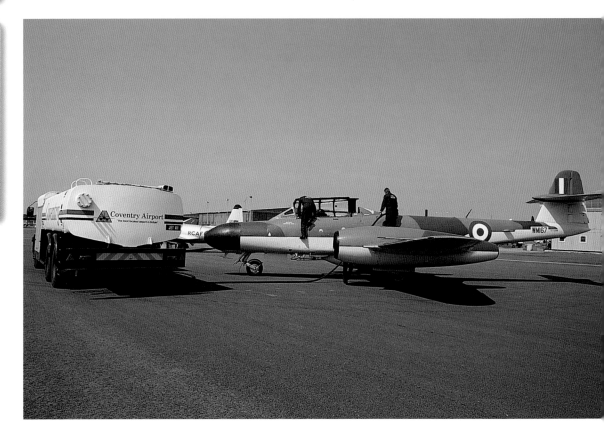

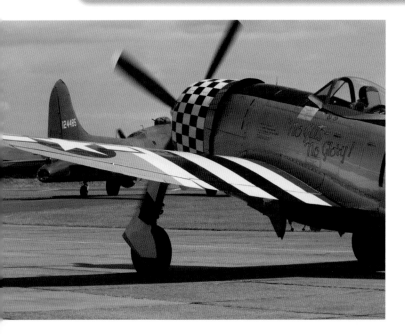

Obstructions, often a bane to photographers, can sometimes be put to good use by including them in the frame. This fuel bowser, for example, clearly states that the Meteor was photographed at Coventry Airport, Warwickshire, UK.

This P-47 Thunderbolt would have made a fascinating photograph on its own, but the composition has been improved by including the B-17 Flying Fortress in the background. The significance of pairing the two is that, during World War II, Thunderbolts provided escorts to the B-17s.

Access to a high viewpoint will often allow both types of photographs to be taken by using a wideangle and a telephoto lens respectively. Stepladders, a colleague's shoulders, control towers, car and hangar roofs (obviously with due permission) are all worth considering as a means of elevating the camera.

When more than one aircraft is to be included in the picture, try varying the composition. In addition to photographs that include all the aircraft, try using the closest aircraft to frame those behind it. With compositions such as this, care must be taken to ensure that all of the aircraft are in focus; use the depth-of-field preview button to ensure that this is the case. Conversely, if it is impossible to exclude undesirable background elements from the frame, try using a wide aperture to create a shallow depth of field and throw the background completely out of focus.

Another option to consider is adding human interest by including aircrew or groundcrew; even airshow spectators can sometimes improve the composition.

Whilst this Avro Tutor could have been photographed from ground level, by raising the viewpoint with a pair of stepladders it was possible to hide a row of aircraft parked in the distance, behind the upper wing.

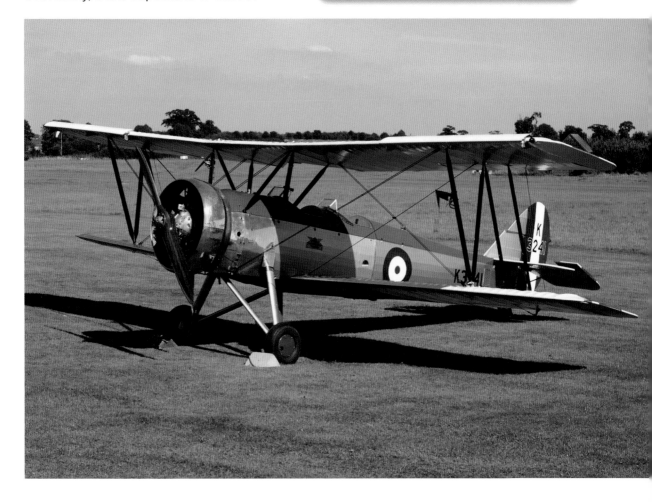

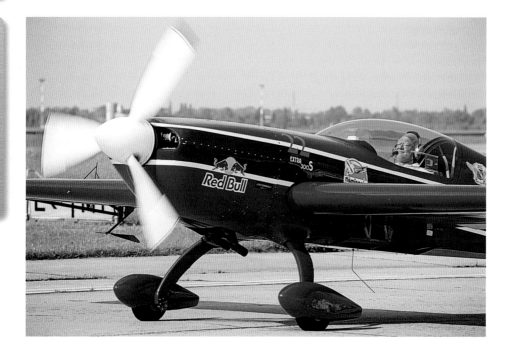

⬆ Using a 300mm lens has emphasized the powerful engine of the Extra 300S aerobatic aircraft as it taxies back after a display. Although the tail wheel has not been included in the photograph, careful framing has ensured that the image is still balanced.

⬇ Composition is often a compromise. Faced with the problem of excluding a row of parked cars in front of these aircraft at a fly-in at Popham airfield, Hampshire, UK, a three-quarter front viewpoint was chosen even though the de Havilland 60 Moth obscures the Dragon Rapide in the background.

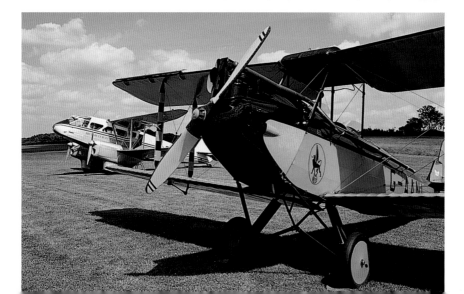

Predict the shot

With moving subjects a large part of the composition should be planned before the shot is actually taken. Think about where the aircraft is coming from and where it is going to, and consider any obstructions that may appear along that route. Pre-plan as much as you can before the opportunity for the shot arises and previsualize in your mind the way in which you wish the final image to appear.

⊙ By predicting where the Airbus A340-600 would taxi after its display, it was possible to frame the photograph to include the World War I Albatross B2.

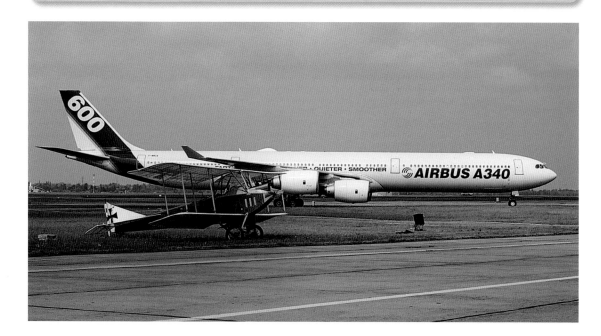

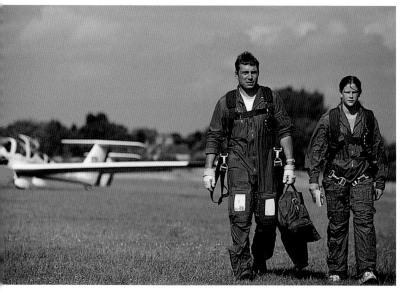

⊙ It's worth thinking about more than just the aircraft. This Air Training Corps cadet and instructor made an interesting subject as they walked from their Grob 109 Vigilant motor glider at RAF Henlow, Bedfordshire, UK after a sortie.

FOCUS ON

KEEPING IT SIMPLE

Unless the background is an essential element of the image – a particularly relevant location, for example, as these two photographs of BAE Hawk advanced trainers show, the simpler the better. In spite of its bright, special colour scheme to mark the Hawk's 30th anniversary, the photograph of XX261 is rather spoiled by the distracting background. This compares with the more pleasing photograph of Hawk T.1A, XX159, positioned against a relatively plain background.

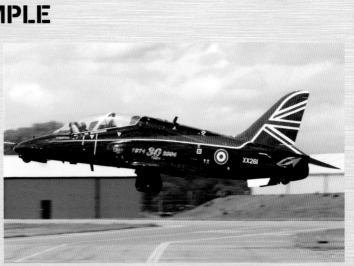

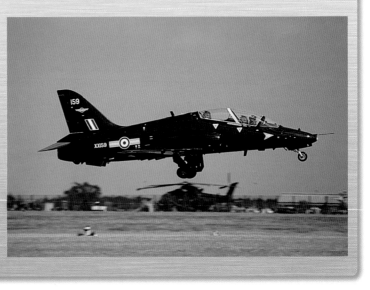

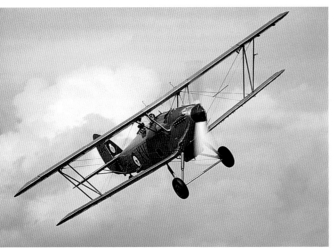

Colour photography need not be gaudy to be successful, as this almost monochromatic photograph of a Hawker Hind proves.

Colour and composition

Colour (assuming that you are not shooting in black & white) is an important part of composition that is often overlooked. The interplay of colours is very important in the success or failure of each image, and the varying colour schemes of aircraft can be either a help or a hindrance. Just because the colours of an aircraft are not particularly vibrant – as is the case with camouflage – doesn't mean that the image as a whole cannot be colourful. Look for details to add a splash of colour if required. Otherwise, concentrate on getting an accurate exposure and an effective composition, letting the subject speak for itself.

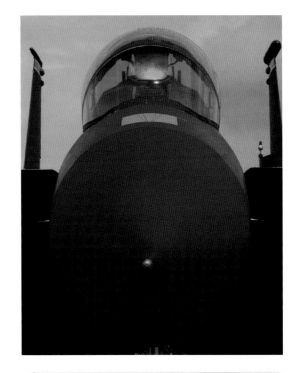

A yellow warning sign lifts the otherwise rather drab image of a 617 Squadron Tornado about to be towed. With the occasional missile known to have been inadvertently fired from aircraft on the ground, such warnings should be treated with respect!

Although predominantly monochromatic, the green head-up display in the cockpit of this F-15E Eagle, photographed with a 100–400mm zoom lens, gives a splash of colour and lifts what would otherwise be a dull photograph.

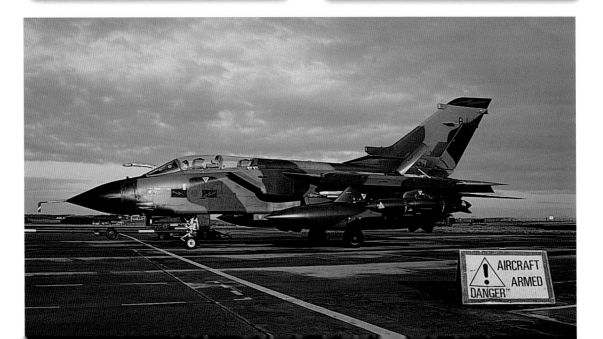

COMPOSITION

One of the greatest reasons that beginners are frequently disappointed is the small image size, particularly in photographs of aircraft in flight. The aircraft that filled the frame when the shutter-release button was pressed somehow appears to shrink during processing and emerges little bigger than a pinhead. I suspect that the main reason for the smaller than expected image is 'blinkered' concentration on the subject, without retaining an awareness of its size in the viewfinder. The solution is to be aware of the whole scene as it appears in the viewfinder. Telephoto lenses are a real necessity for photographing distant aircraft.

Sloping horizontals are another common fault with beginners to photography. This can be caused by trying to keep the aircraft level in the viewfinder as it takes off or lands, or by the camera moving as the shutter-release button is pressed. This can be cured by holding the camera firmly, pressing the shutter slowly (do not jab it) and making sure that you are aware of the whole of the viewfinder.

At all times try and keep an awareness of people and objects in the immediate vicinity of the subject. Countless photographs have been spoiled by someone or something appearing in the field of view just as the photograph is taken.

As was discussed in the section on action shots (see pages 74–9), placing the nose of an aircraft too close to the edge of the frame can create a sense of blocked motion. So, while it is normally a good idea to obtain as large as possible an image of the aircraft, you should bear this in mind and avoid cramping the frame.

Some airshow organizers allow access to aircraft on the flight line before the flying display begins. The Shuttleworth Collection has guided tours for a small fee. The rear cockpit of the Trust's de Havilland Cirrus Moth was photographed with a standard zoom lens.

Jabbing the shutter-release button, or not being aware of the background, can result in a sloping horizon. The latter was the case when taking this photograph of a taxiing Saab Viggen.

Night & low-light photography

Night and low-light photography is one of the most rewarding disciplines – however, it is also one of most difficult. The two main tools that the photographer is armed with: flash and long exposures – are difficult to master but can provide some exciting effects when you do so.

Flash

Flash is particularly useful for interior shots such as cockpits, hangars and museums. As mentioned in the section on equipment, most of these situations call for a wideangle lens, which in turn requires a compatible flashgun or adaptor.

Traces of aircraft navigation lights and aircraft in reheat make for interesting subjects. This F-14 Tomcat is being catapulted off the American aircraft carrier USS *America* just after midnight in the Adriatic Sea. Not having a tripod, the camera was rested on the carrier's island during the exposure of around two seconds. The wavy line was caused when the catapult hit the stops and the whole ship vibrated. But this, the red colour cast and movement on the deck all add to the atmosphere (and won the photographer first prize in a monthly photographic-magazine competition).

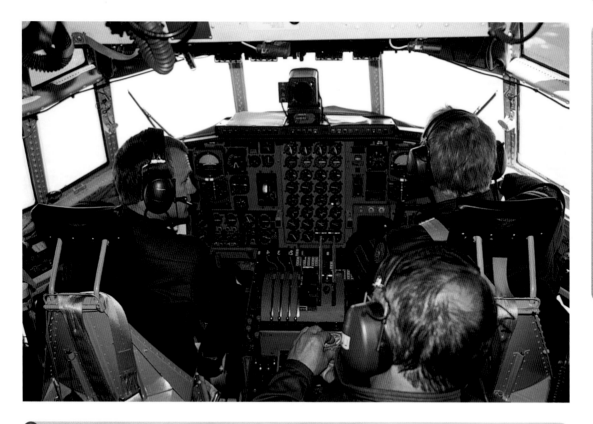

Since September 11, 2001 the increasing concern over terrorism has made it extremely difficult for the general public to get access to the flight deck of airliners. Consequently, photographs such as this – which could once have been part of the family holiday album – are no longer so easy to obtain. In fact, this is a VC10 military aircraft, photographed with a 24mm lens and flash. Being above cloud, no attempt was made to balance the exposure for outside the aircraft.

Most modern cameras are fitted with a built-in flash. While this is useful in some situations, the limited power of most built-in units and the fact that they are housed close to the lens means that a separate, dedicated unit is useful. Flash exposure control used to require a little maths; however, modern flash units take the onus of calculation away from the photographer. That is why it is preferable that you choose a flash unit that is fully dedicated to the particular camera that you use.

The flash's power is denoted by its guide number; this gives the maximum distance at which the flash is effective for a given ISO value. In essence, the higher the guide number, the more powerful the flash (although you should be careful that you are comparing like with like – do not confuse a guide number given in metres with one given in feet).

Another important thing to look for in a flash unit's specifications is its coverage. This denotes which focal-length lenses it is compatible with and is particularly important if you are considering using it with either wideangle or telephoto lenses. Some flashguns zoom automatically.

No, this is not an unfortunate pilot being manhandled by air force personnel; it is a Lockheed TR-1 pilot suiting up for a high-altitude reconnaissance mission. It is one of a number of photographs taken to illustrate a magazine article on the aircraft, and has been included to show the variety of subject matter used by aviation magazines.

Flash is normally used in two situations: either as the primary light source or as a secondary, fill-in light. Modern flash units detect which is the case and if they are being used as a supplementary light they power down slightly in order not too fill out any shadows too much. This should have the effect of lifting the shadows slightly, making detail more visible but without making the image look unnatural.

Some museums will allow bona fide photographers access to their exhibits, such as this Messerschmitt Me 109, but it is wise to submit requests in plenty of time. Use as wide a lens as possible (making sure that the flashgun, if used, has sufficient coverage) and try to position the camera in the centre and square on to the instrument panel.

Night & low-light photography

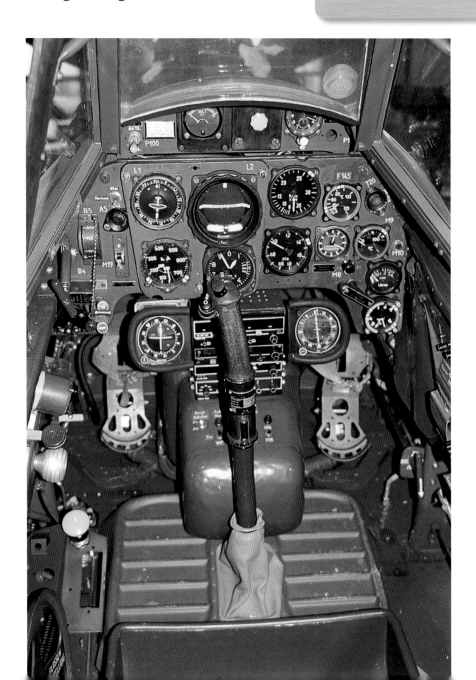

If your camera offers the option of rear-curtain (sometimes called 2nd curtain) synchronization then use this when photographing moving subjects. This will ensure that any streaks of light appear behind the subject, enhancing the sense of motion.

An extreme example of flash is the Swedish company Axstal PhotoAB's development of an airborne flash system using powerful multiple flash heads in an aircraft for air-to-air photographs. The equipment had to be approved by the airworthiness authorities in order to ensure that it wouldn't interfere with the aircraft's systems. How the pilots of the subject aircraft avoided being blinded is not clear.

Photographing this Avro Lancaster at night required a wide range of test exposures, tripod, notebook and flashgun. Using Fuji Sensia 100 ISO film, the exposures ranged from 1/2sec to 16 seconds at f/5.6. This is one of the two or three 'acceptable' images and was exposed for 4 seconds at f/5.6. The Lancaster is regularly displayed at East Kirkby, Lincolnshire, UK. Although not airworthy, it carries out engine runs and taxies out to the old World War II airfield perimeter track.

Long exposures

Long exposures are an alternative to flash photography at night and under low-light conditions. Most cameras offer either a 'bulb' or a 'time' mode that allows the shutter to stay open for shutter speeds slower than thirty seconds. However, it is unlikely that you will require either of these modes; you should be able to manage with those shutter speeds that are preset by your camera.

The most critical requirement of long exposures is the use of a tripod. This should prevent camera shake at slow speeds and ideally should be used with a remote shutter release to minimize the shake from releasing the shutter.

Long exposure times can work well with moving subjects, creating abstract images, such as the one pictured on page 104, where motion is depicted as streaks of light.

Reciprocity failure

When making exposures over one second the law of reciprocity may start to fail. This means that they can be difficult to predict and the meter may make inaccurate recommendations. Normally you will need to expose for slightly longer than the suggested shutter speed.

It is often worth staying behind after airshows finish to take those 'different' photographs. It may be the uncluttered aircraft on static display, the departing aircraft making its only flight of the day, or an aircraft being put to bed for the night. This Avro 504K was photographed in front of its hangar minutes before 'lights out'. The warm colour cast caused by the artificial lighting could be removed for publication, but exudes the atmosphere of the situation.

FLASH

The world of flash photography is subject to a number of common problems. Firstly, and most commonly, if the subject is underexposed, it is likely that the flashgun is simply not powerful enough for the job. Light intensity falls off with the square of the distance between camera and subject, and outdoor subjects do not even have the benefit of reflected light off walls, floor and ceiling, as do many flash photographs taken indoors.

It is possible to extend the coverage of your flash by using a flash extender. These attach to the unit itself and, by limiting the spread of the light, enable it to cover a greater distance. At the opposite end of the scale, wideangle adaptors can ensure that there is sufficient light to cover lenses with short focal lengths.

If you are taking flashlit photographs of people and you find that the lighting is too harsh, then you can invest in a flash diffuser. These soften the light striking the subject, giving images a more natural appearance. Flash diffusers can also be used to soften harsh spots of reflected light from shiny subjects.

Even some of the larger aircraft have fairly restricted cockpits, requiring a wideangle lens to record all of the instrumentation. This is the boom operator's station of a KC-135 Stratotanker. The two windows at the top of the photograph are used by the operator to watch the refuelling aircraft while controlling the refuelling boom. Taking photographs in limited light like this requires a flash, and the use of a wideangle lens means that a wideangle adaptor is also necessary.

In the air

For many photographers, air-to-air is the ultimate challenge in aviation photography, capturing aircraft in their natural element against backdrops of cloudscapes, sea or land, and from almost every conceivable angle.

Although many of the techniques are common to those used when taking pictures from the ground, there are three 'musts' that are specific to air-to-air photography: flight safety *must* be paramount, all participating pilots *must* be

With no control over the positioning of these Jaguars waiting to refuel from the Royal Air Force TriStar tanker, from which this photograph was taken, this rather balanced formation was pure chance. A photogenic cloudscape has also helped make a pleasing composition, which was carefully framed with a 70–210mm zoom lens.

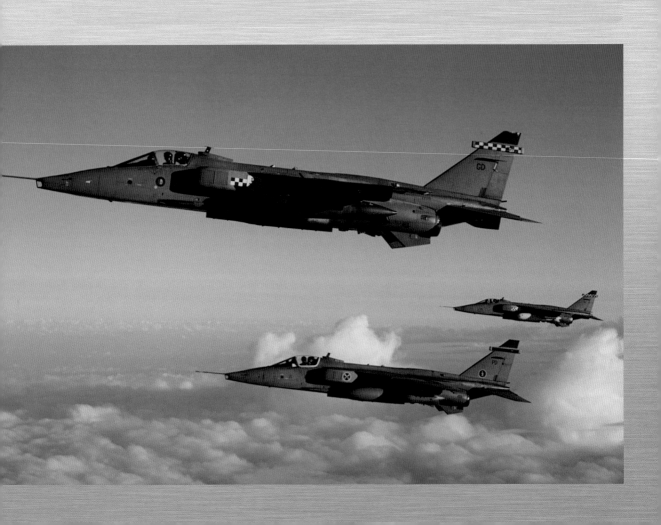

experienced in formation flying, and the flight *must* be planned in detail before take-off and the plan rigidly adhered to.

In the cold light of day it may seem that emphasizing the crucial importance of flight safety is superfluous. However, once airborne, with the adrenalin flowing and having invested a lot of money on the sortie – in aircraft, photographic equipment and time – it is all too easy for safety to be sacrificed for 'one more shot'. Be warned!

Ensure that all participating pilots are skilled in formation flying. Most military pilots are, but the chances are that you will be flying with civilian pilots, and very few private pilots are trained to fly in formation. Do not assume that pilots are experienced; always ask!

Pre-flight planning is essential, not only for safety, but also to brief the pilots on the photographs you want to obtain. Sketches of the photographs you would like to take

⊕ Careful and thorough planning is essential for air-to-air photography, not just for the pilots involved but also in this case the aircraft and air traffic control at the Sutton Bank glider site in Yorkshire, UK. This is located next to the White horse used as a backdrop for this photograph of Jet Provost trainers from RAF Finningley, Yorkshire, taken in the mid-1980s.

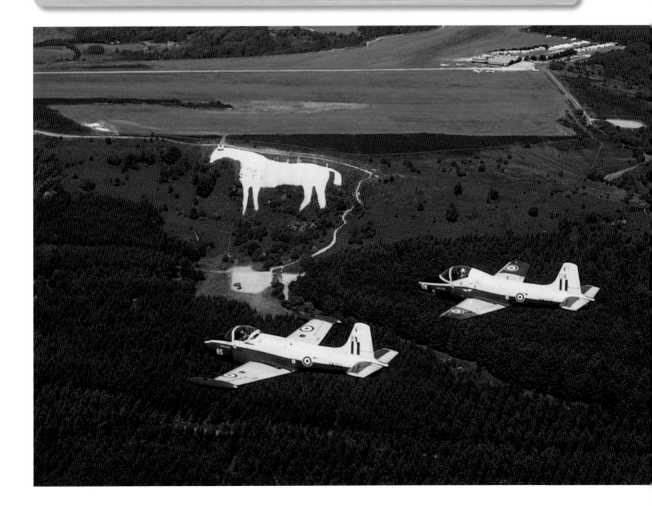

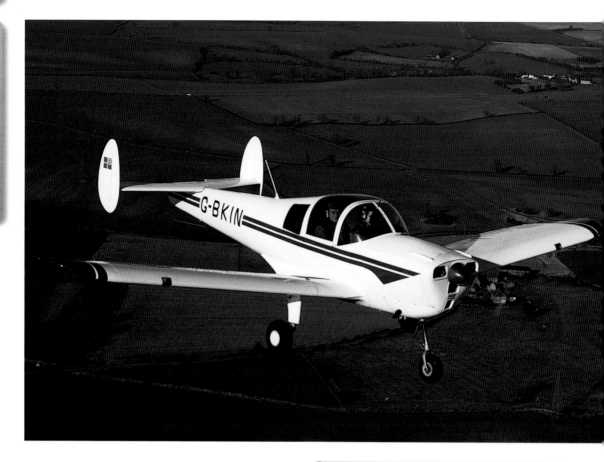

are useful briefing aids and can be used for route and formation planning. Unless flying with experienced service or display pilots, it is wise to keep the sortie simple. Even straight and level flight in an echelon formation, with the subject aircraft rocking its wings, can produce a pleasing variety of photographs. Variations on this theme are gentle formation turns and changes in altitude of the subject.

Your pilots should be aware of the restrictions due to such things as minimum height over built-up areas, controlled airspace, and the potential risk from low-flying military aircraft. However, it is a good idea to discuss the proposed sortie with one of the participating pilots, well before the flight itself, in order to have it approved. Should there be any aspects of the sortie that might transgress aviation-authority

In some respects air-to-air photography is easier than ground-to-air. However, it relies on precise flying by the pilots of all the aircraft involved, and very clear briefings. This is an example of the type of photograph that can be obtained of one light aircraft from another, in this case from a Cessna 152 of an Aircoupé.

regulations, there is then time to re-plan the flight before the final briefing. If the pilot has air-to-air photography experience, then he or she may well suggest additional ideas.

Although the aircraft will have radios, they may well be needed for communicating with ground stations such as air traffic control. So do not assume that you will be able to give instructions over the radio in

flight; any use (if at all) is likely to be restricted to a brief countdown for the start of a manoeuvre. Consequently, with the exception of the intercom – which will allow you to communicate with the pilot of your aircraft – all communication should be via pre-briefed, unambiguous hand signals.

Points to consider when choosing a camera aircraft are obstructions, such as wing struts; removable windows or doors to avoid reflections; and most importantly, compatible performance. Some variation in performance between the aircraft is acceptable. For example, I have successfully photographed a Spitfire and a Jet Provost from a Cessna 172.

Equipment should be kept to a minimum, but do not skimp on film if you are using it. Whenever possible, I take two SLR camera bodies (one for insurance) with a wideangle zoom lens and a telephoto zoom lens.

If it is necessary to shoot through the cockpit canopy or other glazing, try to have it cleaned before take-off. Avoid reflections by keeping the lens as close to the glazing as possible. With some aircraft, reflections

Gliders are extremely smooth platforms for air-to-ground photography, have nice large canopies, and trial flights are relatively inexpensive. These gliders were photographed with a 35–70mm lens, whilst awaiting aero-tows at Newark, Nottinghamshire, UK. The red glider provides foreground interest.

can be avoided by removing the passenger or baggage door. Alternatively, consider shooting through the clear-vision panel that is found on many light aircraft and gliders.

One of the advantages of air-to-air photography is that although the aircraft may be flying at high speed, their relative velocity will be low. However, fast shutter speeds are still advisable to reduce camera shake due to high-frequency vibration, which is present in most aircraft, especially helicopters. Care must, therefore, be taken not to let the camera rest on any part of the structure, such as the cockpit canopy.

All camera equipment, when not in use, should be securely stowed – a lens cap fouling one of the flight controls could have catastrophic consequences. Lastly, always remember to say 'thank you' to the pilots involved; this is best done by remembering to send them a selection of complementary photographs.

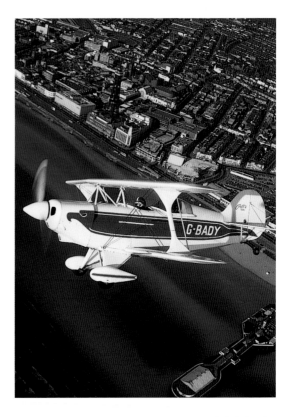

Photographed from a Cessna 172, using a zoom lens, the tower and pier were deliberately included in the picture of a Pitts Special, as the company which owned it operates out of Blackpool Airport, Lancashire, UK. As with all air-to-air photography, detailed pre-flight planning is essential.

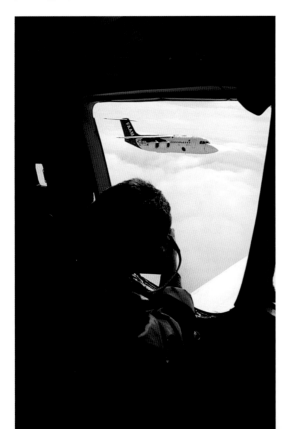

Professional freelance photographer Dave McIntosh during a photo shoot for BAE Systems of the BAE 146 Atmospheric Research Aircraft. Dave used a medium-format Hasselblad and digital SLR during the assignment, and the camera aircraft was a Piper Seneca. Note that the window has been removed to prevent reflections and maximize image quality.

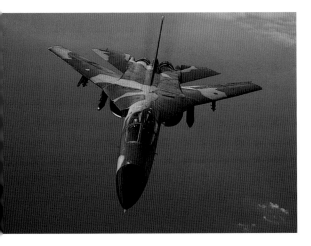

There are two ways of taking air-to-air photographs of aircraft head-on. One is to mount the camera facing rearwards in a pod attached to the aircraft, and the other is from an aircraft that allows the photographer a clear view rearwards. This photograph of an F-111 swing-wing strike aircraft was taken from the boom operator's position of a USAF Boeing KC-135 Stratotanker in-flight refuelling aircraft.

During aerobatic manoeuvres g-forces increase the effective weight of the photographer and equipment; 2g doubles the weight, 4g quadruples it and so on. Most manoeuvres during photo shoots are limited to around 4g, not much compared with the 8–9g pulled in combat, but enough to make raising and lowering the camera tiring. This view of a Phantom was taken in the vertical format as it was intended for use as a magazine cover.

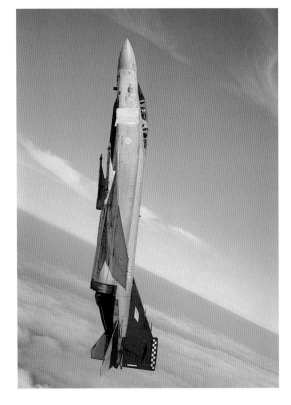

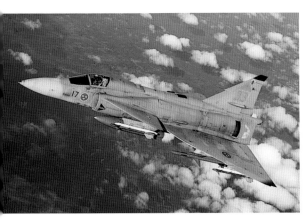

Air-superiority grey camouflage is notoriously effective in hiding aircraft against sky backdrops, hence the orange Day-Glo markings on this Swedish Air Force Saab Viggen to increase its visibility. When photographing aircraft 'down sun', care must be taken to avoid shadows – note the shadow of the camera aircraft just clipping the left wing.

➡ The boom operator's view of an F-111 about to be refuelled over the North Sea. A wideangle lens was used to include the full width of the aircraft, which is only seven metres away from the tanker.

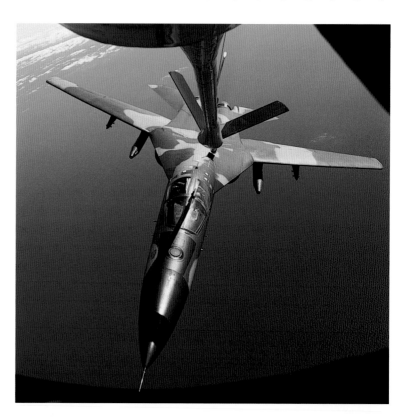

⬆ Air-to-air photography calls for the aircraft involved to be evenly matched for speed; otherwise it is difficult for the pilots to maintain formation for any period of time. The Royal Navy Historic Flight's Fairey Swordfish was photographed from the open doorway of a Royal Navy Sea King helicopter.

⬆ Although the current generation of combat aircraft have less cluttered cockpits, earlier aircraft such as the Buccaneer were not the best camera craft, as may be appreciated from this view from the rear cockpit. A 28mm lens reveals the miniature detonating cord attached to the cockpit canopy (the zig-zag pattern) and the plates on top of the front cockpit ejection seat.

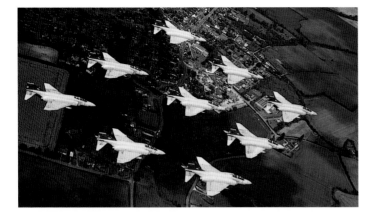

Photographed from the back seat of a 'whipper-in' Phantom, the nine-aircraft formation was practising for a disbandment fly-past of 56 Squadron. The task of the whipper-in aircraft is to fly around the formation and ensure that everyone in the formation is where they should be. Not all photographers have the stomach for the constant high-speed 'jinking' involved. The red splash of colour in the bottom left of the picture is a field of poppies.

Not for nothing was the Starfighter called 'the missile with a man in it'. As may be appreciated from this self-portrait, taken with a 24mm lens, the cockpit is not particularly spacious. There is no room to store lenses or a spare camera body, and film has to be carried in flying-suit pockets. Air-to-air photography in combat aircraft is further hindered by the need to wear an oxygen mask, bone-dome, gloves, an immersion suit (if flying over water during winter), a g-suit, and by being strapped tightly to an ejection seat. As you can see, it is enough to bring the photographer out in a sweat.

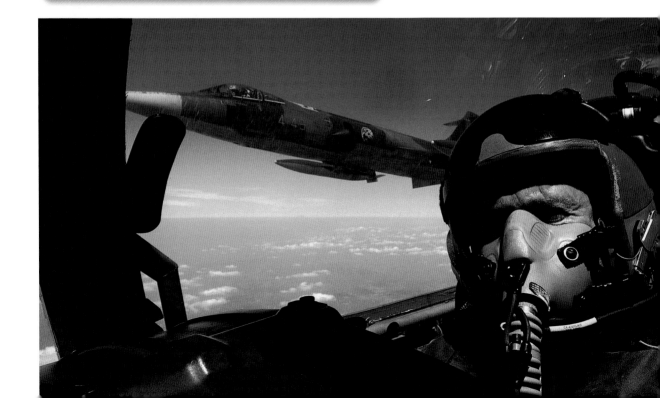

Subjects

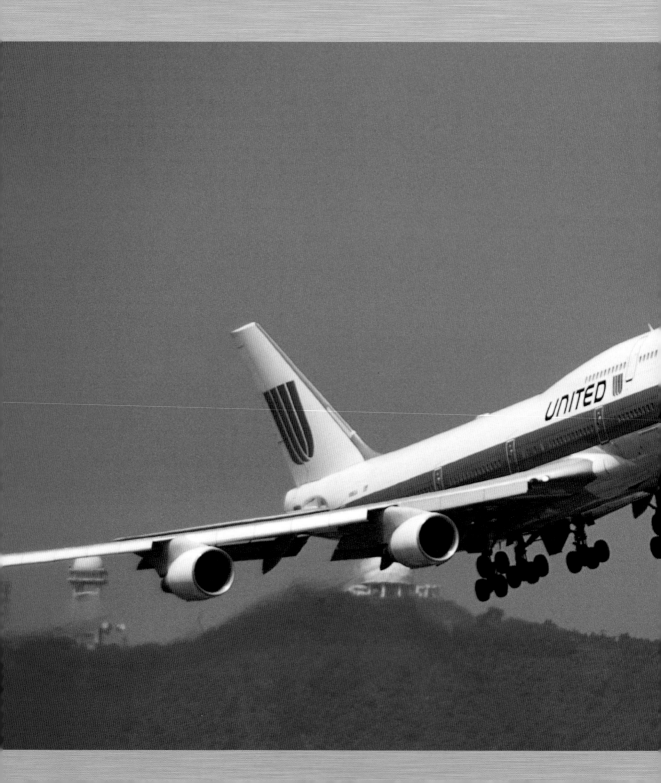

Now that the equipment you need and the techniques that are necessary to take aviation images have been covered, along with the type of images that you might take, it is time to look at the most important part of any photograph: the subjects.

The combination of a telephoto lens and tight cropping emphasizes the majesty of this United Airlines Boeing 747.

Airshows

During 2004 over 300 airshows were held in Europe and the US. They varied in size and participation, from informal light aircraft fly-ins and military 'open-house' displays, to the Oshkosh Experimental Aircraft Association Convention, Wisconsin, US, which drew some 10,000 visiting aircraft and almost 700,000 visitors.

To take full advantage of airshows, it is advisable to arrive early and be prepared to stay behind until the majority of visitors have left. These are the times when you are likely to have the opportunity of taking uncluttered photographs of the static displays. The lighting is also more interesting, and you will miss traffic jams.

To the general public, Saab is best known for its cars, but to the aviation enthusiast Saab has a reputation for producing a range of exciting aircraft. The widely differing configurations of the six combat aircraft in this mixed formation, spanning almost half a century, were captured by waiting until the aircraft were seen in plan view. From top to bottom, the formation comprises Lansen, Draken, Saab 105, Gripen, Viggen, and trailing is the Tunnan.

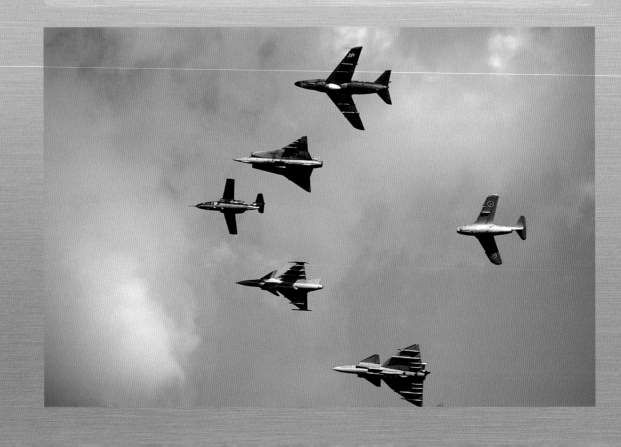

A variation on airshows is the combined flying display and concert. Usually held in the evening, these offer slightly different opportunities for photography, as the lighting created by the low sun can be colourfully dramatic. A low camera angle and a 35mm wideangle lens were used to good effect during a flying display by the Yak Duo at the Old Warden, Bedfordshire, UK, Flying Proms in 2003.

A wideangle zoom lens is often the best tool for aircraft in the static park; while at most airshows, the minimum focal length needed to obtain a reasonably sized image of an aircraft in flight is 200mm. However, you may find that this limits in-flight shots to side-on views. For greater scope, such as aircraft climbing away and head on, a 600mm lens is more useful.

Allowing yourself a full day will also give maximum variety in the direction of lighting. If colour rendering is critical and the lighting is too warm first thing in the morning, or as the sun sets, fit a cool-down filter to balance the light; those with digital cameras may be able to adjust the white balance manually or automatically.

Unless you have specific priorities, it is often advisable to photograph the largest aircraft first, as these tend to be the most difficult to take without people intruding. Details, such as squadron markings and weapons, which can easily be photographed from the crowd barrier, are best left until last. Although you will probably want to exclude people from most photographs, it is often worth taking one or two photographs of the show, with crowds and sideshows. These are likely to increase in interest over the years, relating the exhibits and styles of the period.

The traditional place to photograph the flying display is the runway-threshold area. This is where the aircraft are stationary for a while prior to take-off, and where they flare for touchdown. With a few exceptions, however, photographs taken from here tend to be rather unimaginative and static. Although this is fine for record shots, a point approximately midway along the runway is better for more dynamic pictorial or action photographs.

As far as possible, aim to position yourself in line with where the aircraft have just lifted off. Of course, not all aircraft will rotate at the same point but, with experience, a good compromise position can soon be established. This also places you nearer to the display datum, which is often close to the centre of the crowd line. Perhaps the most important consideration of all, however, is to try as far as possible to avoid having to shoot into the sun.

Aerobatic teams such as the Patrouille de France make colourful subjects. This photograph was taken with a 100–400mm zoom lens and 1.4x teleconverter. Manoeuvres such as this can be anticipated by observing earlier displays, as they seldom change much.

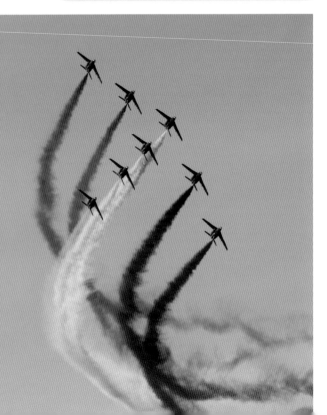

This Battle of Britain still-life composition was part of a World War II Royal Air Force diorama at the Imperial War Museum, Duxford, Cambridgeshire, UK. It was isolated from the other artefacts with a standard zoom lens.

Although the English Electric Lightning was phased out of operational service in late 1988, the Lightning Preservation Group at Bruntingthorpe Airfield, Leicestershire, UK, keeps two aircraft in taxiing condition. One of its Lightning F.6s was photographed with a 100–400mm zoom lens, being prepared for a high-speed reheat run.

By suitable positioning along the runway crowd line, it is possible to capture aircraft just before they touch down, or in this case of a 17(R) Squadron Eurofighter Typhoon – just as it streams its brake parachute, which adds extra visual interest.

FOCUS ON

BEFORE AND AFTER THE EVENT

At many of the larger airshows, aircraft often arrive a day or two before the display begins and depart the day after. These so-called arrival and departure days give photographers the chance to capture aircraft in flight that will be displayed statically on the day.

At large airshows aircraft often stay overnight at the display location and leave en masse the following day. In such cases, it is well worth requesting permission to attend the departure day. Photographers are often afforded facilities denied during the formal airshow, with closer access to the aircraft. This Harrier GR.7 was photographed with a 70–210mm lens on one such occasion.

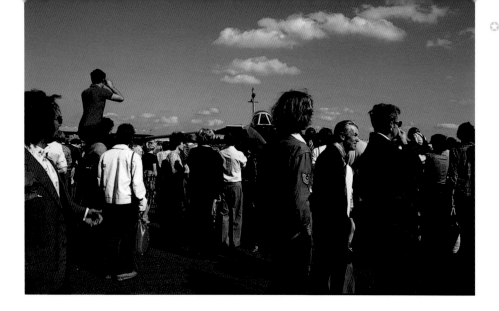

A typical airshow scene, showing the difficulties in taking photographs of aircraft in the static park. Easing through the crowd and using a wideangle lens is one solution; moving back, standing on a ladder and using a telephoto lens is another. It must be said that ladders should only be used with due care so as not to obstruct the view of others, particularly during the flying display.

There are probably more preserved aircraft on the airshow display circuit now than ever before, and it is easy to get blasé about even the most exotic aircraft. One such example is the Bristol Blenheim, photographed here during a display at Old Warden, Bedfordshire, UK. This aircraft was a fairly common sight at UK airshows until it was severely damaged on landing in 2003.

FOCUS ON

PHOTOGRAPHING PEOPLE

It is very easy, when surrounded by so many aircraft, to forget that there is a wealth of other photographic opportunities in front of your lens. As the following images show, there is a wide range of fascinating people, so why not capture them to add a little bit of life to your portfolio? Note that some countries place restrictions on photographing people.

Airshows offer some excellent opportunities for human-interest photographs, and often the individuals are so preoccupied with events that a standard-focal-length lens can be used to get close without attracting attention.

Airshows are an excellent source of people pictures, such as this engineer cleaning the propeller blade of the French Nord Noratlas, prior to its flying display at the Coventry Airshow, Warwickshire, UK, in 2003.

⊕ An increasing number of re-enactment groups attend military airshows and make fascinating subjects for photography. Many stroll around and are more than happy to pose for photographers. These two characters are dressed in World War II United States Air Force uniform. Note the low camera angle to hide a distracting background.

⊕ Human-interest subjects abound at airshows and can add a touch of humour. This group used rather appropriate 'flags' to mark their spot for a Flying Proms concert at Old Warden, Bedfordshire, UK.

⊕ This attractive spectator just happened to be walking past a Dutch F-16 Fighting Falcon, when its ground crew suggested she don a flying suit and pose for photographers on the wing of their aircraft.

⊕ A 28–104mm zoom lens was used to photograph this couple dressed in authentic World War II clothes. They were carefully posed against a backdrop of an equally authentic World War II RAF ambulance and hangar, at the Imperial War Museum, Duxford, Cambridgeshire, UK.

⊕ An example of a fascinating aircraft that was sadly short-lived is this replica of Charles Lindbergh's Ryan NYP. It was photographed at an airshow in Sweden in September 1997, and destroyed in a fatal accident at Coventry, Warwickshire, UK in May 2003. When modern background surface detail is omitted, subjects such as this have a timeless feel.

⊗ This photograph of a Sukhoi Su-27 'Flanker' landing during the RAF Finningley Airshow, Yorkshire, UK, in 1991 clearly shows the difficulties facing photographers trying to shoot through a mass of spectators more than six deep along the crowd line.

⊕ Note the exhaust smoke as this Lockheed Super Constellation starts its engines. The moral of this photograph is to make sure your equipment is secure. Minutes after this photograph was taken there was a gale from the propeller slipstream as the Constellation taxied out.

⊙ What could be more sedate than a balloon launch on a calm summer's evening? Taken at the annual Northampton Balloon Festival, Northamptonshire, UK, with a standard lens. There are countless opportunities among these colourful subjects. There are a number of similar events around the country throughout the year, and there are few restrictions on photography.

Airfields

Both civil and military airfields can offer a varied collection of aircraft. Not surprisingly, civil airfields give greater freedom, often allowing photographs to be taken on the field itself. But in either case the extent to which you are allowed access

should always be carefully checked and any necessary authorization obtained before the shoot.

In-flight photographs are often best taken on the approach – that is, downwind of the runway in use. The optimum location for

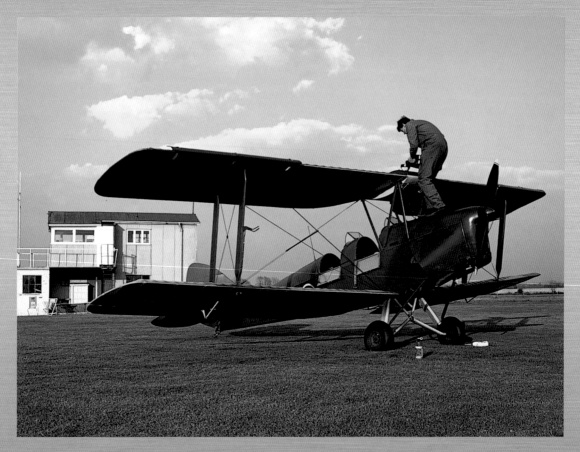

⊕ Looking remarkably like a Tiger Moth, this is in fact the sole airworthy de Havilland Queen Bee – a pilotless drone conversion that was used for target practice during World War II (so it is not surprising that there is only one left). It was photographed with a standard lens at RAF Henlow, Bedfordshire, UK, being refuelled. This is typical of the photographs that can be taken at airfields. That said, permission must always be obtained first from the authorities in the control tower.

Airfields

Including the control tower has given another dimension to what would otherwise have been a rather dull photograph of a Piper Vagabond and Piper Super Cub. The tower also clearly locates the photograph as being taken at Leicestershire Airport, UK. The occasion – a Piper aircraft fly-in – was typical of several fly-ins held at airfields throughout the year. Advertised in general aviation magazines, such as *Today's Pilot*, they provide wonderful informal opportunities for photographs. Before venturing out onto the airfield, make sure to obtain permission from the authorities – usually located in the control tower.

approach photographs can be found from a large-scale map of the area, or a drive around the airfield. The presence of other photographers will usually confirm the right spot. Anther excellent source of information on airfields for 'spotters' is the Internet, with a number of websites giving directions on how to find the best 'photo-spots'.

Civil airfields

Many civil airfields offer the facility of photographing aircraft on the field, from car parks or viewing areas. However, permission to enter the aircraft parking area must be sought from the airfield authority first. At no time should you walk near the runway in use or near taxiing aircraft.

Military airfields

Military airfields are another matter altogether. It goes without saying that all signs displayed around the airfield, such as those stating that 'crash gates are not to be obstructed' must be obeyed. Under no circumstances should you set foot on the airfield without permission. There is normally no problem taking photographs outside the airfield boundary, but this varies.

⊕ By including the barbed wire in the frame, the military nature of these Boeing AWACS aircraft was emphasized. This photograph was taken from the vantage point on top of stepladders.

⊕ Most of the airfields built throughout the UK during World War II have been destroyed. Those few remaining buildings, such as this control tower at Kings Cliffe, Northamptonshire, are a nostalgic reminder of the sacrifice paid by an earlier generation for our freedom. It was photographed with a 24mm lens. Note that permission to visit most sites such as this must be sought from the landowner.

Some bases will provide guided tours for recognized organizations such as photographic societies. This is an excellent opportunity to photograph a number of aircraft in their working environment. Any requests should be addressed to the Station Public Affairs Officer.

A number of military airfields have gate guardians – aircraft at the entrance of the base, which often reflect the station's most memorable days. Most are located just inside the security barrier, this necessitates obtaining prior permission from the Public Affairs Officer to photograph them.

Disused military airfields are a legacy of the hundreds built for and during World War II. Although some have completely disappeared, there are a few remaining whose dilapidated buildings and overgrown runways, perimeter tracks and hard-standings make wonderful photographic subjects. Some airfields also have memorials to those airmen and women who served there during the War.

One of the many gate guardians at airfields around the world, this Buccaneer is displayed at the South African Air Force base, Waterkloof. Although most gate guardians are situated outside restricted areas, it is still strongly recommended (and sometimes necessary) that permission be sought before taking photographs.

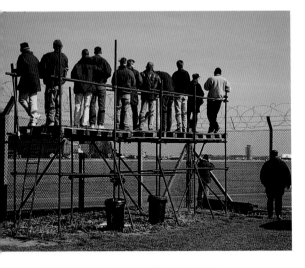

In spite of concern over security at airports and military establishments, there are still many opportunities to photograph aircraft unhindered. Such is the case here, where a friendly landowner has not only made his field available to photographers, but has even gone to the pains of erecting a raised platform in order that photographers can have a clear view over the wire fence surrounding RAF Mildenhall air base, Suffolk, UK.

QUICK TIP

If you followed the plight of the British aircraft spotters arrested in 2002 in Greece on charges of spying, you should not need warning about the folly of photographing aircraft (military or civil) in countries where you do not know the law. It is not worth the risk – if in doubt, do not photograph. In any case, there has been so much foreign participation at European and American airshows in recent years, that there are few fresh types still to see.

Airports

Airliners make colourful subjects and can easily be photographed in flight, while on landing approach, or static, from the public observation areas within the airport itself (although there are very few of these). Advice for taking photographs at and around airports is the same as that given earlier for airfields. The main difference is that you are unlikely to obtain full access to the aircraft. That said, some airports will arrange visits to the control tower and other facilities for recognized groups. Anyone interested in such access should contact the Airport Press Officer.

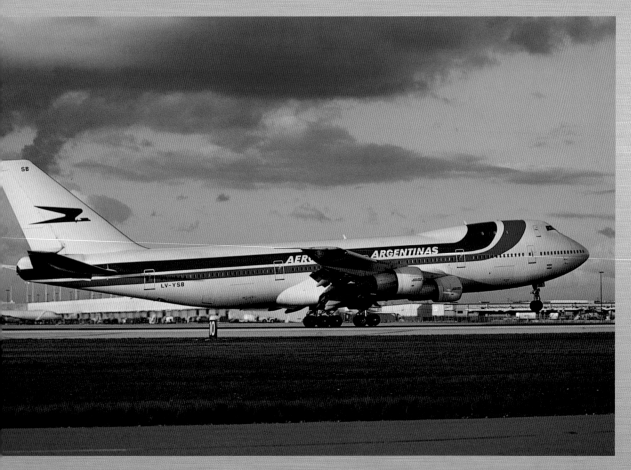

An example of the photographs that can be taken through the fence at Miami International Airport, Florida, USA, is this Aerolíneas Argentinas Boeing 747 landing. As can be seen, the authorities have considerately positioned the vantage points close to the touch-down point.

Not all airports are as 'photographer-friendly' as Miami International Airport, Florida, USA which has strategically positioned holes in the perimeter fence. That said, following the events of September 11, 2001, some of this access has been denied to photographers.

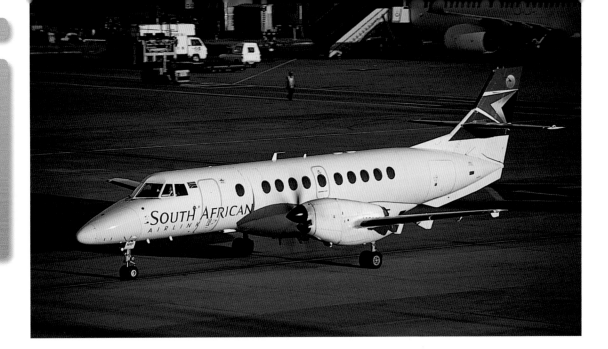

 Although photographed through a tinted departure-lounge window, the colour cast is hardly noticeable. In spite of the concern over terrorism a number of airports still have observation areas for photographers and spotters. A 70–210mm zoom lens was used to photograph this South African Airways Jetstream 41.

Alas, with the closure of Kai Tak International Airport, images such as this Boeing 747 turning onto final approach over buildings in Hong Kong, are consigned to history.

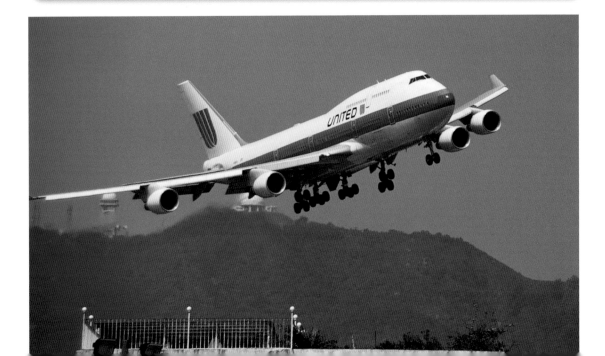

In spite of the less-than-perfect optical qualities of the Virgin Atlantic Airbus A340's cabin windows, through which this photograph of a Manx Airlines BAE 146 was taken, the resultant image is quite acceptable, and illustrates yet another opportunity for the avid aircraft photographer.

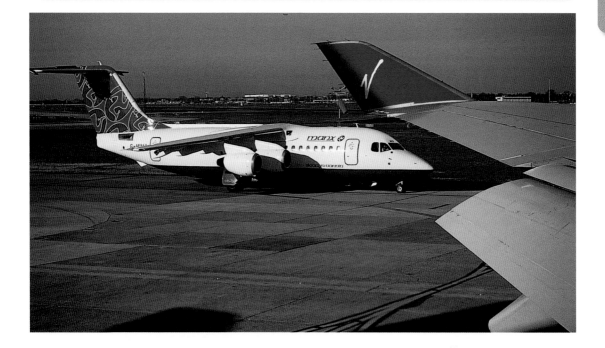

Airliners are normally best photographed on the approach to land, as they are usually closer to accessible vantage points there, than at the upwind end of the runway where they are climbing out. This photograph of a KLM Boeing 747-400 is an exception to the rule and was taken as the undercarriage was retracting during take-off.

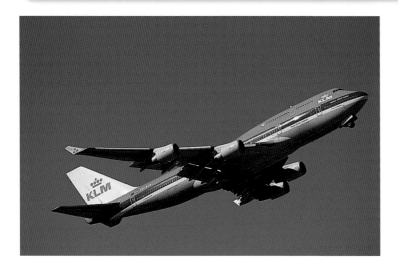

Holidays

Where flying to a holiday destination, photographs taken at the airport can provide an interesting introduction to your holiday photograph album or slide show. Air-to-ground photographs from the cabin windows are best taken with a wideangle lens. Do not worry if the engine or wing tip protrudes into the field of view; they may add interest. Minimize reflections by keeping the lens close to the window and, if possible, wear a dark, plain top. I had some wonderful air-to-air photographs spoiled by the reflections of my striped shirt.

Opportunities abound for photographers who fly on holiday to take air-to-ground pictures. This South African urban scene was photographed as the aircraft was on approach to land.

Holidays are also the time for photographs of opportunity. Low-level jets racing through the Welsh valleys and Lake District in the UK can make particularly dramatic photographs if you are fortunate enough to be in the right place at the right time. If you are enjoying a beach holiday, you may see search-and-rescue helicopters on practice sorties or on routine patrols around the coastline.

Although they may make interesting subjects, stay well clear if they are involved in a real rescue mission. There was an incident a few years ago where a clifftop photographer obstructed the rescue of a young girl lying injured at the foot of a cliff. The photographer was so close to the cliff edge that the helicopter crew were afraid he would be blown off by the rotor downwash.

Every picture tells a story and this one tells at least two. The air–sea-rescue Sea King was photographed from a hotel window early one morning during a search along the North Yorkshire coast at Whitby, UK for a body that had been sighted in the water. 'From a window' because I had been locked in the hotel, my partner having gone off for an early morning jog with the only door key. Lesson one: keep a spare key; lesson two: invest in a telephoto lens (a 200mm lens was just long enough) – and I suppose a third lesson would be: be prepared. The good news is that it was a false alarm, and I did get my photograph.

Obviously a major consideration when taking your equipment on holiday is its well-being. Check that it is appropriately insured, and if possible never leave it in your hold luggage; by carefully selecting a minimum of kit you should be able to keep your hand luggage within the airline's restrictions. Film should also never travel with hold luggage; although it is normally fine to submit it to hand-luggage X-ray machines, hand inspections are preferable, so request one if you are concerned. Digital memory cards are immune to the effects of X-rays.

Remember always to turn up with plenty of time before your departure. Carrying masses of camera equipment can lead to hand inspections which are time-consuming and might result in unforeseen delays.

If an airline permits the use of cameras on board their aircraft and there are no objections to photography around the airport, look for opportunities such as this when arriving and departing from airports. Including the terminal building in some shots is worthwhile as it increases the potential sales market. This American Falcon Boeing 737 was photographed during turnaround at Buenos Aires International Airport, Argentina.

FOCUS ON

KEEPING YOUR EYES PEELED

Aircraft are seen in the most unusual and unexpected places, so it always pays to have a camera to hand. This is where compact cameras come into their own. This precariously perched Cessna, advertising a shopping mall was photographed near Fort Worth, Texas, USA.

This sorry-looking Lightning F.2A is slowly rotting alongside the A1 at Balderton, near Newark-on Trent, UK. A standard-focal-length lens is ideal for uncluttered and relatively easily accessible subjects such as this. Facing as it is, almost due north, photographs of the right-hand side may be taken before noon and the left-hand side, as seen here, in the afternoon.

Museums

As a result of an increase in nostalgia, perhaps brought about by the 'baby boom' of the 1940s, there has been a growth in the number of aviation museums and a keenness to preserve our aviation heritage.

Among the many museums in Europe and America are those specializing in aviation, such as the Air and Space Museum, Washington DC, USA. Others, such as the Science Museum, London, UK, are not specialized, but contain interesting exhibits for photographers and enthusiasts alike.

There are few limitations, if any, to photography, although some museums may prohibit the use of a tripod. Indoor exhibits, lit by artificial light, may also result in

Museums, often a rich source of inspiration, can also occasionally provide surprises, such as this Lockheed Ventura awaiting restoration, at the South African Air Force Museum, Swartkop.

Museums

peculiar colour casts if using colour film. The museum curator, or your local camera dealer, should be able to advise you on the type of filters to use to correct the colour balance. Alternatively, use a film balanced for artificial light. Most digital cameras will allow you to alter the white balance (or will alter it automatically).

Some museums are prepared to open their doors outside normal hours for organized groups, such as camera clubs and aviation societies. This affords the opportunity to take pictures without the usual hordes of visitors being present, and you may even be allowed special access to cockpits and inside protection barriers.

⬆ Museums are an excellent source of material and few are better than the Air and Space Museum, Washington DC, USA. Being located close to a window, this Bell X-1 was illuminated by daylight.

Village & pub signs

A number of villages and public houses, that have an association with aviation, reflect this in their signs. Whilst village signs tend to be fairly permanent, those on pubs tend to change frequently at the whim of the landlord or brewery. Spotting and photographing pub signs with an aeronautical theme can be quite an enjoyable pastime, almost as much as sampling their beer and food.

Imitation is the sincerest form of flattery. Could it just be coincidence that The Airman public house sign was almost identical to the self-portrait of the author in a BAE Systems Hawk? Only another aircraft has been added. The Airman at Henlow, Bedfordshire, UK, has now been converted to a private house. The self-portrait was taken with a 24mm lens manually focused and the aperture wide enough to give sufficient depth of field to render myself and the Hawk in focus. Framing the Hawk and myself needed a little bit of luck and the co-operation of both pilots.

Villages in the UK that have had a close association with aviation, often reflect this in their boundary signs. Cardington, Bedfordshire, UK, is still dominated by two huge airship hangars, one of which was the home of the ill-fated R-101. Side lighting has brought out the relief in this carved wooden sign.

This memorial at Kings Cliffe, Northamptonshire, is one of many located throughout the UK, dedicated to those air force personnel who served during World War II. As access is unlimited, a standard lens is quite adequate. Note the imaginative way in which the memorial reflects the RAF and USAF links at the base by the Mustang and Spitfire wings on the two pillars.

KINGS CLIFFE AIRFIELD
STATION 367

TO COMMEMORATE THE
ETERNAL MEMORY OF THOSE
AMERICAN, BRITISH, BELGIAN
AND COMMONWEALTH AIRMEN
WHO GAVE THEIR LIVES IN
THE CAUSE OF FREEDOM
1939 – 1945
LEST WE FORGET

After the shoc

It is tempting to neglect the part of photography that follows the shoot: unprocessed films, boxes of transparencies or prints, not to mention literally thousands of digital files, can all pile up disturbingly fast. A little discipline is all that is required, and, as with any hobby, putting in the hard work will ultimately make it reap even greater rewards – perhaps even financial ones.

FA-71
60 TH ANNIVERSARY

FIGHTER SQUADRON

After the shoot it is important that you look after your images, in order to get the most out of photographs like this Belgian Air Force F-16A.

Filing

Photographers intending to market their work will need a quick reference and retrieval system for their pictures. So, although a chore, it is a useful discipline to record and file photographs as soon as they are processed or downloaded.

I presently record all my film photographs on a form held in A4-size loose-leaf binders and filed alphabetically by aircraft type.

⊕ No, this is not the result of cross processing, or over-exuberant digital manipulation. It is an authentic World War II camouflage scheme applied to high-altitude reconnaissance Spitfires. Colour schemes such as this are often short-lived and should be captured whenever the opportunity arises.

Each photograph – in my case each 35mm transparency (until I recently began taking digital images) – is given a reference number. This is marked on the transparency holder with an indelible pen. Negatives can be similarly referenced.

Information on the form consists of: slide reference number, type of aircraft, mark of aircraft, serial number, date and location of where the photograph was taken, attitude of the aircraft and any comments. To reduce the amount of space required for all of this information, I use codes for location and attitude. For example, 'YVN' is shorthand for Yeovilton, UK, and 'GTT' stands for ground, three-quarters tail.

Similar systems can be employed on a computer, using cataloguing software that is ideally suited for this sort of work and will allow selective retrieval, using a word search.

Prints and negatives

There are several ways of filing prints: in boxes, in transparent sleeve albums or mounted in traditional albums – all of which can be stored by type or in chronological order. As my photographs are primarily for selling, I keep my prints in boxes to make them easier to retrieve. The choice is yours, and if you wish to show your photographs to friends or family, then using an album will probably be the best bet for you.

Negatives are best filed in transparent sleeves, held in loose-leaf binders with their contact sheets. This helps to keep them in good condition. Ideally they should also be

kept separately from the associated prints as this will cut down the risk that both will be damaged or lost at the same time.

Transparencies

As with prints, there are a number of products on the market for filing transparencies. They include trays which can be loaded ready for use in slide projectors, slide boxes in a variety of shapes

and sizes, and transparent sleeves. I use the latter, with metal bars to suspend the sheets in a filing cabinet. The sleeves can also be filed in a loose-leaf binder, and I find that they enable me to view a number of transparencies at the same time.

Digital images

Digital images may be referenced in a similar way to slides and negatives, although the codes may have to be abbreviated a little more. Images can be filed using one of the many commercially available software packages, such as Adobe Photoshop Album or Extensis Portfolio. These allow images to be catalogued into categories and found quickly, even if they are stored on CDs rather than the computer hard drive. In addition to the identifying captions and keywords that can be added, the information embedded in each digital image (such as when it was taken, and exposure details) is often recorded automatically. Before investing in a software package, talk to your local software or photographic dealer, to ensure that it is compatible with your computer and that it will meet your needs.

FOCUS ON

EDITING

Before filing your pictures in whichever system you find best suits your purpose, be ruthless in sorting out unsuccessful photographs. This can be painful, particularly when it means throwing out photographs of your favourite aircraft, but if you do not do this you will soon run out of storage space – either physical or virtual. You will also find that as your standards and your ability improve with experience, you will wish that you had been more critical from the outset, as you may find that you have to sort through too many unsatisfactory images to find one of acceptable quality.

Selling

Selling images is something that many amateur photographers don't even consider. This is a big mistake, as if your images are up to standard it only requires a little more time and dedication to start making money from them.

Markets

One only has to browse the shelves of any magazine outlet to appreciate the potential afforded by the number of specialist aviation publications. Most are published monthly and rely heavily on material

Magazine and book covers traditionally need portrait-format images, but this landscape-format photograph of an English Electric Lightning was used to illustrate the cover of the author's book *RAF Colour Album*. It is also worth noting the human interest.

submitted by readers. In addition, there are a number of aviation and defence magazines, which are sold on subscription only and so do not appear on the shelves.

Of course, it is not only aviation magazines that publish photographs of aircraft. There are potential outlets for the innovative aviation photographer in many other specialist magazines, as a study of them will show. Other users of aviation photographs include newspapers, modelling and company 'in-house' magazines, poster companies, calendar and postcard agencies, CD sleeves, jigsaw-puzzle manufacturers and book publishers. Enthusiast collectors of aviation photographs are yet another outlet, a business that has been boosted by the rapid growth of Internet selling. Ironically, despite the increase in digital photography, there are some extremely high prices being paid for original transparencies.

Being long and thin, aircraft are not the easiest subjects to photograph for magazine and book covers, which tend to require portrait-format subjects. Three or four loops in formation were flown with varying degrees of success, before this photograph of an Italian Air Force Lockheed F-104 Starfighter was captured. Due to difficulties in translation, there were problems in positioning the aircraft in relation to the sun. This image was used in the vertical format for a magazine cover.

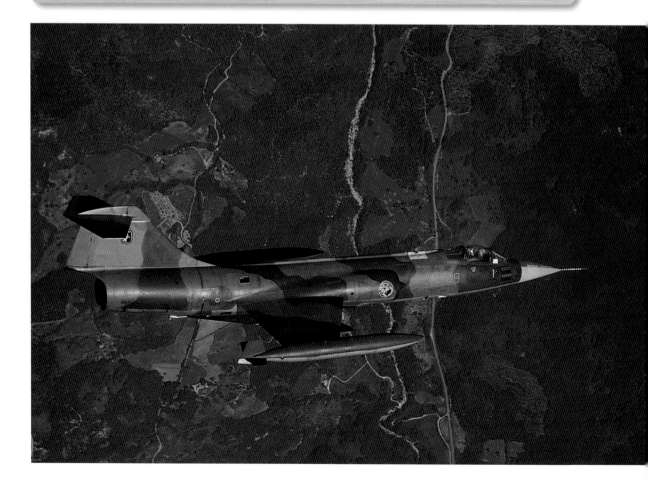

⬆ Currently flying in the silver and red colours of the Norwegian Army Air Force, for many years the Shuttleworth Collection's Gloster Gladiator appeared in the dark earth-and-green camouflage scheme representing an aircraft of 247 Squadron RAF. These two photographs, taken 13 years apart, make an interesting comparison for both aircraft enthusiasts and aero modellers.

⬇ This photograph of a replica Bristol Boxkite is timeless. The Boxkite was built for the film *Those Magnificent Men in Their Flying Machines* (1965) and photographed with a 300mm lens. Subjects such as this are ideal for selling to birthday card agencies and non-aviation magazines.

Good cover photographs are difficult to come by, and this is one of the banes of an editor's life. These two photographs of a Boeing E-3 AWACS airborne early warning and control system aircraft are examples of images that could make fine covers, though would need to be cropped in the lower image.

Events such as Sir Richard Branson, the owner of the Virgin group, celebrating the 150th anniversary of the first manned flight in a fixed-wing aircraft, by flying a glider based on one of Sir George Cayley's designs, provide great opportunities for sales in newspapers and magazines. This camera angle was chosen to give a clear view both of Sir Richard and the unique glider. A telephoto lens was needed to fill the frame whilst standing at a distance with a pack of newspaper photographers.

As 617 Squadron has a maritime strike role, this Tornado was posed against the Scottish shoreline. Being flown by the RAF's first female fast-jet combat pilot, Jo Salter, not only was it a suitable news item at the time, but it will remain a valuable reference photograph.

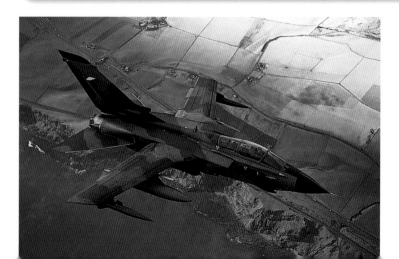

Websites provide another outlet, either through existing sites, which take a percentage of sales (like an agency), or through a personal site.

All photographers who are seriously interested in selling their work are strongly recommended to invest in a directory of publications. The titles available vary depending on the country in which you live, but there are many useful sourcebooks of information on a wide range of journals and book publishers, including details of their requirements and fees.

Research

Analysis of the market is essential, otherwise both you and your potential customer could waste a lot of valuable time. If the latter occurs, there is a real danger that your material would no longer be even

⊕ Pilots of the future? These Air Training Corps cadets were photographed proudly posing in front of a Tornado GR.4, by one of the Tornado aircrew. Apart from being a little different for the family album, photographs like this could be worth submitting to the ATC newspaper for publication.

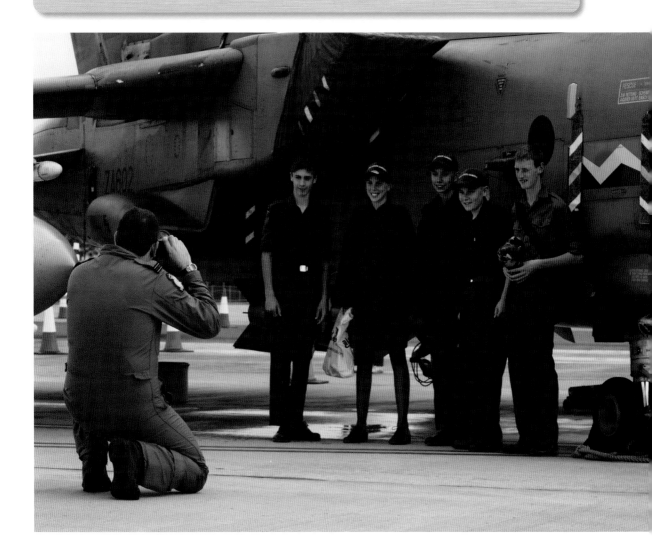

considered by the customer involved. Worse still, the world of aviation photography is remarkably small and word would soon be spread of your ineptitude.

This is not to suggest that the photographs are necessarily poor, but rather that they are inappropriate. Anyone with a passable knowledge of aircraft and the ability to use a camera has the potential to make money from photography. The difficulty is in identifying the markets and submitting appropriate material.

It is necessary to determine not only the subject matter published by the magazine (book publisher, calendar, or whatever), but also the medium and style. Does the publication use transparency, print and/or digital? Does it prefer topical news images, record shots or pictorial, single photographs or a spread? How much information is required to accompany the image(s) – a short caption or a couple of hundred words of text? Answers to all of these questions can be obtained from a careful study of the market, followed by a brief telephone call, letter or e-mail to the potential customer. This is to confirm your understanding of the customer's requirements, and indicates your intention to submit material. This will enable you to identify the market(s) most suitable for the type of photographs you take. Alternatively, if selling photographs is your primary interest, then the results of the market survey will enable you to determine the range and style of subjects published. Do not be disheartened by a neutral response to your call; until a working relationship has been developed with a publisher, editor or agent, they are traditionally non-committal about offers of material from new contributors.

Whilst the Internet is a useful research tool, in general it is a poor substitute to seeing the actual product.

Researching the market can be made less onerous to a large extent by selling photographs through a website or an agent. The main difference between the two is that websites are passive, in that they rely on potential customers to access them, while an agency will actively market your photographs (it may also have its own website). Both commercial websites and picture agencies will demand a fee for their services, which, in the case of an agency can be around 50% commission. While this may seem high, it must be appreciated that an agent will promote your photographs to many more markets than you are likely to have access to. Agencies advertise in magazines for professional photographers and their details can also be found in the reference books mentioned already.

FOCUS ON

MULTIPLE SUBMISSIONS

It is unprofessional to submit the same material to competing publications at the same time. That said, if the subject is sufficiently newsworthy it might be prudent to syndicate the photographs, together with a note stating where the other copies have been offered. An alternative way of capitalizing on a 'scoop' is to take a number of photographs of the event or aircraft from different angles.

Presentation

It goes without saying that all photographs submitted for publication must be correctly exposed, accurately focused and clean. They must also be correctly captioned and contain your contact details. I use self-addressed adhesive labels for prints and transparencies, and a labelling pen for CDs. Computer-literate photographers, with suitable printers, may prefer to print these details directly onto slide mounts and CDs.

Most magazine and book publishers will accept 35mm transparencies or digital images on CDs or as e-mail attachments. When submitting transparencies, be warned that they are often returned damaged to some extent. There is also a real danger of the material being lost in the post or possibly by the publisher. With this in mind, whenever possible, it is worth shooting several frames for syndication and as spares, or submitting images as digital scans.

All photographs submitted by post should be accompanied by a short covering letter offering the photographs for a 'one-off' reproduction at the magazine's usual rate – or for a fee you consider suitable – and a caption sheet. The captions should be typed and concise, including a brief description of the subject, and stating where and when the photograph was taken. Ensure that the photographs are protected in the post by stiff card; slides should be in glassless mounts and presented in transparent sleeves.

It is polite to include a stamped, addressed envelope in which the material that you have supplied can be returned – hopefully after use. Some publishers will send a card notifying you of the safe receipt of the pictures; if you have not heard after two weeks or so, it is worth making a telephone call to ask if the material has arrived safely.

⊙ As with most branches of photography, it helps to have a reasonable knowledge of the subject in order to illustrate its more interesting characteristics. This composition shows the unique combination of the Buccaneer's folding wings and 'clam-shell' airbrakes.

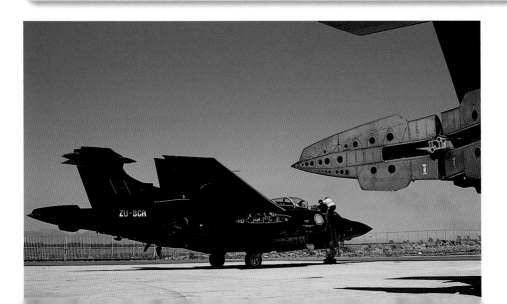

FOCUS ON

INSURANCE

When posting images, make sure that they are insured for the relevant amount. however, be aware that many postal services and other independent insurance services will not cover what is known as 'consequential loss'.

This means that while the cost of film, processing and so on, may be covered, the perceived value of the image in terms of potential sales almost certainly will not.

The growth of digital photography has been a mixed blessing to magazine editors. Whilst it enables images to be transmitted almost instantaneously, a large percentage of photographers are still relatively inexperienced regarding reproduction requirements, particularly image size. If in doubt, ask. For most book and magazine publication digital images should be 300dpi and A4 size. On behalf of editors I should like to make a plea for all CDs to be accompanied by a clearly referenced 'contact sheet' of the disc's contents. There is nothing so frustrating and time-consuming as having to wade through countless unlabelled images. Likewise, please ensure that all images sent by e-mail are clearly captioned and of a suitable format. Finally,

whilst there is a great temptation to shoot considerably more frames than when governed by the cost of film, be selective when submitting digital images. An editor inundated with numerous images of the same subject may not have time to view them all, particularly if they are large files.

If you are fortunate enough to obtain a 'scoop', get your photographs to the newspaper or magazine as soon as possible. Telephone the editor first, to describe what you have photographed, confirm his or her interest and seek advice on how the material should be delivered. If the photographs were taken on film, in exceptional cases the editor will arrange for the film to be processed; if they are digital images, you will probably be given an e-mail address.

◀ There is no need to be constrained by rectangular slide mounts. Commercially produced foil masks are available in a wide variety of shapes and sizes, such as this circular one. Alternatively, kitchen tinfoil may be used if you need to mask straight edges.

Fees

Before rushing out to book your world cruise in anticipation of a sale, be warned that, with the exception of staff photographers, there are only a very few people making a living solely from the proceeds of aviation photography. Some of these have amassed a large archive of photographs, including collections bought from retired photographers. From personal experience, publication fees per photograph have ranged from zero (and the magazine concerned kept the original transparencies) to £200 (around US$300). Note that the fee payable is for a one-off use; it is usual to receive 50% of the initial payment for subsequent reproduction.

Buoyed with the low recurring costs of digital photography, there are an increasing number of enthusiasts willing to see their work published for no more than an acknowledgment, and many enthusiast magazines are run on a shoestring budget.

Fees for postcards and posters vary from publisher to publisher, but expect on average £200 (around US$300) for world greetings-card rights for three years.

Always read the small print in any contract; and you are strongly urged to retain copyright on all of your images.

Although there may not be much financial reward in aviation photography, it is satisfying to see one's photographs in print, and payment helps to offset the expense of materials and travel. Whilst on the subject of expenses, all payment received from the sale of photographs must be declared to the tax authorities. This income can, however, be offset by justifiable expenses.

◉ Look out behind you! Many airshows have family entertainment such as this bouncy castle, seen behind the F-15 Eagle at the Imperial War Museum, Duxford, Cambridgeshire, UK. Images such as this are an amusing foil for the more serious exhibition subjects and could well be published in a subsequent airshow programme or events calendar.

Useful contacts

Visiting Airfields and Airshows

While it is impossible to note all of the contact details for the many airports, airfields and airshows around the world, there are a couple of points that, although already mentioned in the text, bear repeating. Firstly, the best person to contact about gaining access to any site or event is the press officer or community liaison officer of the relevant location. Secondly, you are most likely to meet with success if you are a member of an organized group, such as a photographic society.

Information on the dates, locations and attractions of individual events is available from a number of sources, including the websites of the magazines listed below, the Internet and the local press.

Aviation Publications

The following publications are available in several countries around the world. For more information on finding them in your location visit the relevant website.

They are also a good place to consider selling your aviation photographs and the type of subject that each magazine is interested in is also listed below the contact information for each publication.

AIR International

PO Box 100 Stamford,
Lincs
PE9 1XQ
UK

Email: editorial@airinternational.com
Web: www.airinternational.co.uk

Photographs of commercial and military aircraft currently in service worldwide, particularly topical, newsworthy images.

AirForces Monthly

PO Box 100 Stamford,
Lincs
PE9 1XQ
UK

Email: edafm@keymags.co.uk
Web: www.airforcesmonthly.co.uk

Photographs of modern military aviation currently in service worldwide. Particularly topical, newsworthy images.

Airliner World

PO Box 100 Stamford,
Lincs
PE9 1XQ
UK

Email: airliner@keypublishing.com
Web: www.airlinerworld.com

Photographs of airliners in colourful liveries and topical newsworthy images.

FlyPast

PO Box 100 Stamford,
Lincs
PE9 1XQ
UK

Email: flypast@keypublishing.com
Web: www.flypast.co.uk

Photographs of historical aircraft and restoration subjects worldwide.

Air Enthusiast

PO Box 100 Stamford,
Lincs
PE9 1XQ
UK

Email: editorial@airenthusiast.com
Web: www.airenthusiast.com

Photographs of historical aircraft worldwide.

Today's Pilot

PO Box 100 Stamford,
Lincs
PE9 1XQ
UK

Email: todayspilot@keypublishing.com
Web: www.todayspilot.co.uk

Photographs of general aviation aircraft and microlights.

Photography Publications

A range of photography publications including *Outdoor Photography* magazine and *Black & White Photography* magazine, as well as books on a variety of photographic subjects are available from:

Photographers' Institute Press

166 High Street,
Lewes,
East Sussex
BN7 1XU
UK

Web: www.gmcbooks.com

Manufacturers

The following is a list of manufacturers' websites that are a useful source of information on a range of cameras, lenses, imaging-software and other equipment that are mentioned throughout *Aviation Photography*. Nationally based sites that offer information that is specific to your location can be reached via the worldwide gateway sites that are listed below, unless otherwise noted.

Adobe

www.adobe.com

Worldwide gateway site for the leading image-editing software company

Canon

www.canon.com

Worldwide gateway site for international camera and photographic equipment manufacturer

Extensis

www.extensis.com

Worldwide gateway site for the cataloguing and other software manufacturer

Four Thirds

www.four-thirds.com

Information on the Four Thirds digital SLR open standard

Fujifilm

www.home.fujifilm.com/gateway/

Worldwide gateway site for camera, photographic equipment and film manufacturer

Kodak

www.kodak.com

Worldwide gateway site for camera, photographic equipment and film manufacturer

Konica Minolta

www.konicaminolta.com

Worldwide gateway site for camera and photographic equipment manufacturer

Nikon

www.nikon.com

Worldwide gateway site for camera and photographic equipment manufacturer

Olympus

www.olympus.com

Worldwide gateway site for camera and photographic equipment manufacturer

Pentax

www.pentax.com

Worldwide gateway site for camera and photographic equipment manufacturer

Sigma

www.sigma-imaging-uk.com – UK
www.sigmaphoto.com – USA

UK and US sites for camera and third-party lens manufacturer

Glossary

35mm film – Photographic film that is 35mm wide. The usable frame size is normally 24 x 36mm, although this depends on the camera type. 35mm film is normally supplied in canisters from which the film is wound and then rewound.

Adobe Photoshop – A widely used image-manipulation program, at the time of writing the most recent version was CS2.

Adobe Photoshop Elements – A cut-down version of Adobe Photoshop.

Ambient light – Light available from existing sources as opposed to light supplied by the photographer.

Angle of incidence – The angle between the incident light falling on the subject and the reflected light entering the camera lens.

Angle of view – The area of a scene that a lens takes in. A wideangle lens has a wide angle of view, while a telephoto lens has a narrow angle of view.

Aperture – The hole or opening formed by the leaf diaphragm inside the lens through which the light passes to expose the film. The relative size of the aperture is denoted by f-stops.

Aperture priority – An exposure mode on an automatic camera in which the photographer chooses the aperture and the camera calculates the shutter speed for correct exposure. If the aperture is changed, or the light level changes, the shutter speed changes automatically.

Aspect ratio – The ratio of the width to the height of an image.

Auto-bracketing – This function enables cameras to automatically take a number of pictures, at different aperture/shutter-speed combinations to ensure a range of exposures – one of which should be correct.

Autoexposure (AE) – The ability of a camera to recommend and set the correct exposure for a particular scene.

Autoexposure lock (AE-L) – A function that records and locks an exposure setting while the user recomposes the picture.

Autofocus (AF) – The camera's system of automatically focusing the image, normally this comprises a number of separate points.

Blower brush – A brush with an air bulb attached, allowing the user to blow away or suck up dust.

Bounced flash – The process by which light from a flash unit is bounced onto the subject, from a ceiling, wall or reflector, in order to 'soften' or sometimes hide unwanted shadows.

Bracketing – The process of exposing a series of frames of the same subject or scene at different exposure settings.

Buffer – The in-camera memory of a digital camera, which stores images before they are written to the memory card.

Burst depth – The maximum number of frames that a digital camera can shoot before its buffer becomes full.

Burst rate – The number of frames per second that a digital camera can capture during its burst depth.

Camera shake – Movement of camera caused by an unsteady hold or support. This can lead, particularly at slower shutter speeds, to a blurred image.

Cast – Abnormal colouring of an image.

Catadioptric lens – see mirror lens.

CCD (charge-coupled device) – A microchip made up of light-sensitive cells, used in digital cameras for recording images.

Centre-weighted metering – A type of metering system that takes the majority of its reading from the central portion of the frame. It is suitable for portraits or scenes where subjects fill the centre of the frame.

Close-up – A picture taken with the subject close to the camera.

CMOS (complementary metal oxide semiconductor) – A microchip made up of light-sensitive cells, used in digital cameras for recording images.

Colour-correction filters – Filters that are used to correct colour casts.

Colour temperature – Description of the colour of a light source by comparing it with the colour of light emitted by a theoretical perfect radiator at a particular temperature expressed in Kelvins (K). Note that 'cool' colours such as blue have high colour temperatures and vice versa.

Composition – The arrangement of the design elements within the picture space.

Contrast – The range between the highlight and shadow areas of a negative, print, slide or digital image. Also the difference in illumination between adjacent areas.

Cool-down filters – Filters that are blue in appearance and have the effect of correcting warm colour casts or introducing cool colour casts.

Cropped sensor – A digital sensor that is smaller than a 35mm frame.

Cropping – Printing only part of the available image from the negative, slide or digital file, usually to improve composition.

Daylight colour film – Colour film intended for use with light sources with a colour temperature of approximately 5400K, for example daylight.

Dedicated – Indicates that a flashgun or other accessory is specially designed for a particular camera or camera range and the exposure is controlled by information passed from the camera to the flash.

Depth of field – The amount of the final image that is acceptably sharp. This is partly controlled by the aperture setting: the smaller the aperture, the greater the depth of field. Depth of field extends one third in front of and two thirds behind the point of focus.

Depth-of-field preview – Some SLR cameras offer the chance to see the available depth of field by stopping down the aperture while the mirror remains in place.

Diffuse lighting – Lighting that is low or moderate in contrast, such as that which occurs on an overcast day.

dpi (dots per inch) – A measure of the resolution of a printed image.

Exposure – The amount of light that is allowed to act on a photographic material. Also, the act of taking a photograph, as in 'making an exposure'.

Exposure compensation – A level of adjustment given (generally) to autoexposure settings. Generally used to compensate for known inadequacies in the way a camera takes meter readings.

Fast lens – A fast lens has a wide maximum aperture (e.g. f/2) to allow more light in and therefore allow faster shutter speeds to be used without underexposure occuring.

Field of view – The amount of a scene that will be included within the frame with a particular lens at a certain camera-to-subject distance.

Fill-in flash – Flash combined with daylight in an exposure. Used with naturally backlit or harshly sidelit or toplit subjects to prevent silhouettes forming, or to add extra light to the shadow areas of a well-lit scene.

Film speed – The sensitivity of a given film to light, measured as an ISO rating.

Filter – A piece of coloured or clear glass, or other material, used over the lens or light source, or between the lens and film to affect the colour or density of the entire scene or certain areas within a scene.

Flare – Non-image-forming light that scatters within the lens system. This can create multicoloured circles or a loss in contrast. It can be reduced by multiple lens coatings, low-dispersion lens elements or the use of a lens hood.

Flash guide number (GN) – A measure of the power of a flash unit. Normally measured in metres, the GN indicates the aperture needed to expose a certain speed of film with the subject at a certain distance from the flash. GN divided by distance equals required aperture (GN/d = a). A GN is usually given for ISO 100 film. When using faster or slower films, the guide number doubles or halves every two stops so, for example, ISO 400 film will deliver a guide number twice as big as ISO 100 which itself is twice as big as for ISO 25. The guide number is given in either feet or metres and it must be specified which.

Flash sync – The flash sync(hronization) speed is the fastest speed at which a camera with a focal-plane shutter, such as SLRs, can work with flash. At speeds faster than the sync speed, only part of the image shot with the flash will be lit.

f-numbers – A series of numbers on the lens aperture ring and/or the camera's LCD panel that indicate the relative size of the lens aperture.

Focal length – The distance, usually given in millimetres, from the optical centre point of a lens element to its focal point.

Focusing – The adjustment made to the distance between the lens and the film (and therefore the focal point) in order to bring the focal plane into coincidence with the film or sensor plane, i.e. to focus the image on the film or sensor.

Foveon – A type of digital sensor which employs three separate layers of sensor to capture red, green and blue light. Compare with Mosaic sensor.

fps – Frames per second.

Grain – When the minute metallic silver deposit that forms the photographic image on film becomes visible it is described as grain.

Graininess – The sand-like or granular appearance of a negative, print, or slide.

Highlight – Very bright part of an image or object.

Hotshoe – An accessory shoe with electrical contacts that is normally mounted over the viewfinder, allowing synchronization between the camera and a flashgun.

Hotspot – A concentration of light on a subject, causing a loss of detail in the highlights. This is a common problem in flash photography.

Incident light – Light falling on a surface.

Incident lightmeter – An exposure meter that measures the light falling on the subject, rather than the light reflected by the subject.

Inverse square law – The law that states that the variation in the intensity of light reaching a subject equals the inverse square of the change in distance. For example, if a light source is moved 10x further away the amount of light reaching the surface will be 100x less.

ISO – The international standard for representing film sensitivity. The emulsion speed (sensitivity) of the film as determined by the standards of the International Standards Organization.

JPEG – A standard compressed image file developed by the Joint Photographic Experts Group.

Kelvin (K) – The scale used to measure colour temperature.

LCD (liquid crystal display) panel – A screen on a camera that provides information in the form of alphanumeric characters and symbols. Often used to display exposure settings, frame count, ISO rating, etc.

Lens – One or more pieces of optical glass, or similar material, designed to collect and focus rays of light to form a sharp image.

Lens barrel – The structure within which the optical elements of a lens are held.

Lens coating – A coating that is applied to a lens in order to diminish unwanted reflections and aberrations such as flare.

Lens hood – A shade attached to the front of the lens to prevent non-image-forming light from entering the lens barrel and causing flare.

Lightmeter – See Incident or Reflected lightmeter.

Medium format – A format that is larger than 35mm and users either roll film that measures approx. $2^1\!/_4$in(6cm) wide

Megapixel – One million pixels = one megapixel. The power of a digital sensor is often given in megapixels: eg. the Canon 20D has as 8.2 megapixel sensor.

Memory card – Any one of a number of removable storage devices for digital cameras.

Metering – Using a camera or lightmeter to determine the required exposure to correctly render a scene.

Midtone – A tone of grey or any other colour that reflects 18% of the light falling on it.

Mirror lens – A telephoto lens that uses a combination of lens elements and mirrors in order to allow long focal lengths in a lens with a relatively short physical length. Also known as a catadioptric lens.

Monopod – A camera support with only one leg. Often used by sports photographers.

Mosaic filter sensor – A filter which is laid over a digital sensor so that each pixel only registers one colour of light. The results are then interpolated.

Motordrive – An automatic mechanism that advances and rewinds film.

Multi-segment metering – A metering system with a number of variably sized and positioned segments to detect brightness levels and calculate an exposure value.

Noise – The digital equivalent of graininess, caused by stray electrical signals.

Opening up – Increasing the size of the aperture of the lens to allow more light to hit the film or sensor.

Overexposure – A condition in which too much light reaches the film or sensor, producing a dense negative or a light print or slide. Detail is lost in the highlights.

Panning – Following a subject's movement with the shutter open while keeping the subject positioned in approximately the same part of the frame. This results in the background blurring but the subject remaining sharp, imparting a sense of motion to the image.

Parallax – The difference in viewpoint between the viewed image and the image recorded on film. This occurs in direct-viewfinder cameras.

Partial metering – A metering mode that is only available on Canon cameras. It covers approximately 9% of the scene.

Pixels – Abbreviation of picture elements, the individual units which make up an image in digital form.

Prime lens – A lens of a fixed focal length.

Program – An exposure mode on an automatic camera that automatically sets both the aperture and the shutter speed for correct exposure.

Rangefinder – A type of viewfinder, or a camera that uses such a viewfinder. Part of the image appears split when out of focus, and continuous when in focus.

RAW – A type of digital file that includes the full shooting information and remains flexible when accessed via the appropriate software.

Rear/second-curtain sync – It is usual for a flash unit to fire as soon as the shutter is fully open. With rear-curtain sync, the flash is fired the instant before the shutter closes. This results in trails of light behind the subject when used in conjunction with a long exposure.

Reciprocity law – A change in one exposure setting can be compensated for by an equal and opposite change in the other. For example, the exposure settings of 1/125sec at f/8 produce exactly the same exposure value as 1/60sec at f/11.

Reciprocity law failure – At shutter speeds slower than one second the law of reciprocity begins to fail for film because the sensitivity of film reduces as exposure increases. This affects different films to different extents.

Red-eye – When photographing people or animals using flash close to the optical axis, the light from the flash can bounce off the blood vessels in the retina of the eye causing the pupil to look red in the image.

Red-eye reduction – Some flash units can be set to fire a sequence of preflashes causing the pupil to contract and the appearance of red-eye to be diminished.

Reflected light – Light reflected from the surface of a subject.

Reflected lightmeter – A light meter measuring light reflected from, rather than light falling on, the surface of a subject.

Rule of thirds – A compositional device that places the key elements of a picture at points along imagined lines that divide the frame into thirds.

Shutter priority – An exposure mode on an automatic camera that lets you select the desired shutter speed; the camera sets the aperture for correct exposure. If you change the shutter speed, or the light level changes, the camera adjusts the aperture automatically.

Shutter-release button – The button or lever on a camera that causes the shutter to open.

Shutter speed – The length of time that the shutter is open, measured in seconds or fractions of a second.

Silhouette – An extreme example of a backlit image in which all surface detail is lost.

SLR (single-lens reflex) – A type of camera that allows you to see through the camera's lens as you look in the viewfinder. The most useful camera type for aviation photography.

Spot metering – A metering mode that takes a light reading from a very small portion of the scene, sometimes as little as 1°.

Standard lens – A standard lens is one that provides approximately the same field of view as the human eye. This equates to a lens with a focal length approximately equal to the diagonal of the frame in use. In 35mm format this approximates to a 50mm lens, for most digital cameras this is closer to 35mm.

Stopping down – Changing the lens aperture to a smaller opening, for example from f/8 to f/11. Sometimes used to mean any reduction in exposure, either in aperture or shutter speed.

Substitute reading – A meter reading taken from an object of known reflectivity that is under the same lighting conditions as the subject.

Teleconverter – A lens that is inserted between the camera body and main len,s increasing its effective focal length. These are most commonly available in 1.4x and 2x versions.

Telephoto lens – A lens with a large focal length, with a narrow angle of view making small or distant subjects appearing larger in the picture space.

Through-the-lens (TTL) metering – A meter built into the camera that determines exposure for the scene by reading light that passes through the lens during picture taking.

TIFF – Tagged image file format: an uncompressed digital image file.

Tripod – A three-legged camera support.

Tungsten-balanced film – Colour film that gives a correct colour balance under tungsten lighting.

Underexposure – A condition in which too little light reaches the film, producing a thin negative, a dark slide, or a muddy-looking print or digital file. There is too much detail lost in the areas of shadow in the exposure.

UV filter – A filter that reduces ultra-violet interference in the final image. Often used to protect the lens.

Vignetting – The cropping or darkening of the corners of an image. This can be caused by a generic lens hood or by the design of the lens itself. Most lenses do vignette, but to such a minor extent it is unnoticeable. This is more of a problem with zoom lenses than fixed focal lengths.

Warm-up filters – Filters that add a warm colour cast to an image, or correct a cold colour cast.

White balance – A function on a digital camera that allows the correct colour balance to be recorded for any given lighting situation.

Wideangle lens – lenses with a wider angle of view than the human eye. Lenses wider than 60 degrees are wideangle, more than 90 degrees is super-wide.

Zoom lens – A lens with a variable focal length that can be altered by the photographer.

Index

Photographers' Institute Press
Castle Place, 166 High Street, Lewes, East Sussex BN7 1XU, United Kingdom
Tel: 01273 488005 Fax: 01273 402866
E-mail: pubs@thegmcgroup.com
Website: www.gmcbooks.com
Contact us for a complete catalogue, or visit our website. Orders by credit card are accepted.

About the author

T. Malcolm English is the editor of *AIR International*, one of the most popular magazines for aviation professionals and enthusiasts. His interest in photography began 45 years ago when he was given his first camera and it has grown ever since. His combined experience of the aviation industry and taking photographs places him in an unparalleled position to reveal the exciting world of aviation photography.